ART OF COLORING

ROGUE ONE

A **STAR WARS** STORY

100 IMAGES TO INSPIRE CREATIVITY

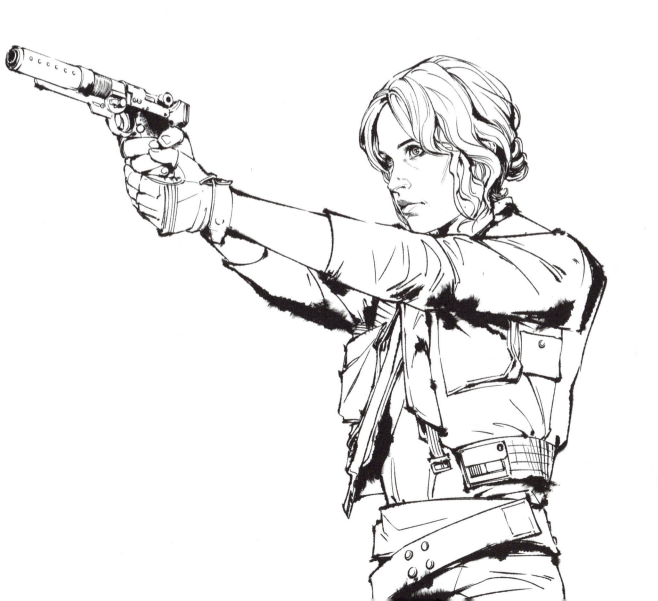

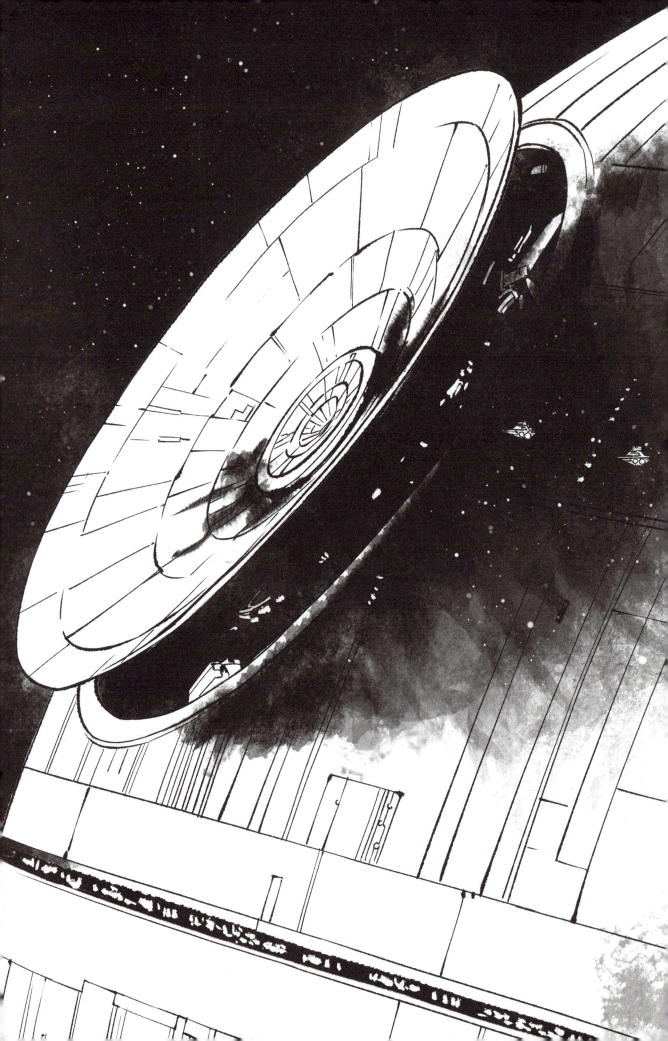

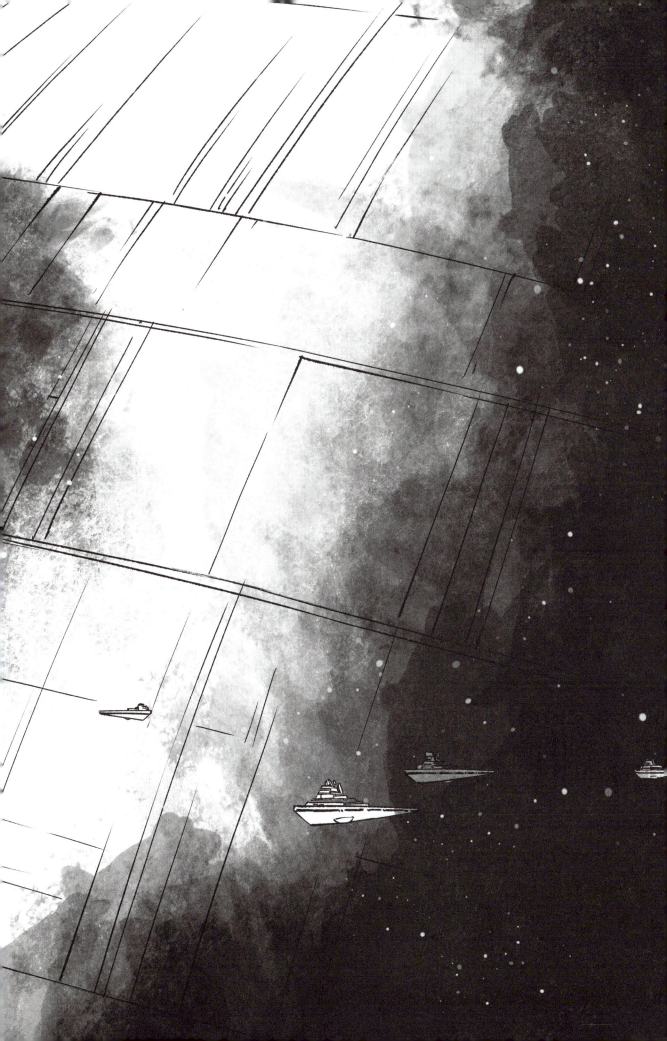

ORSON KRENNIC

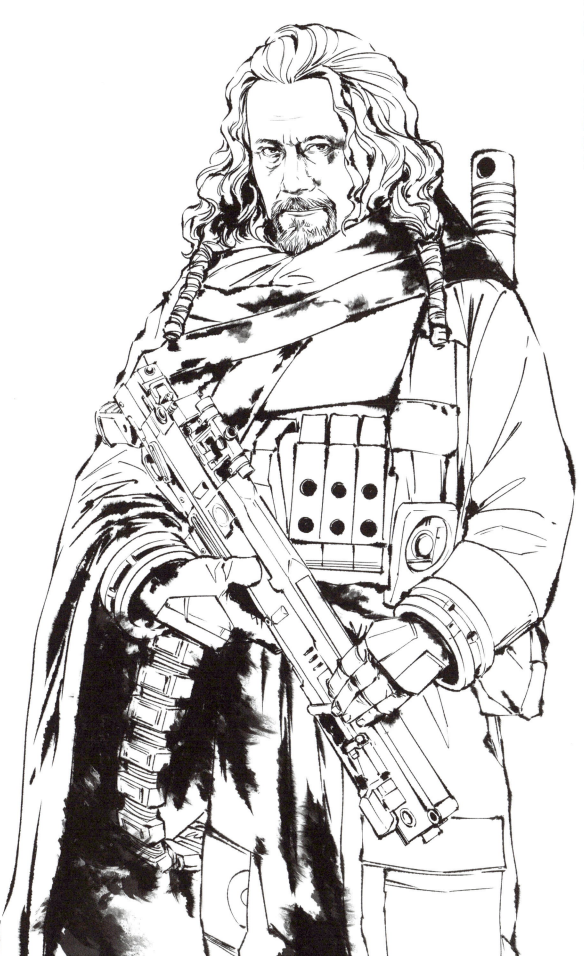

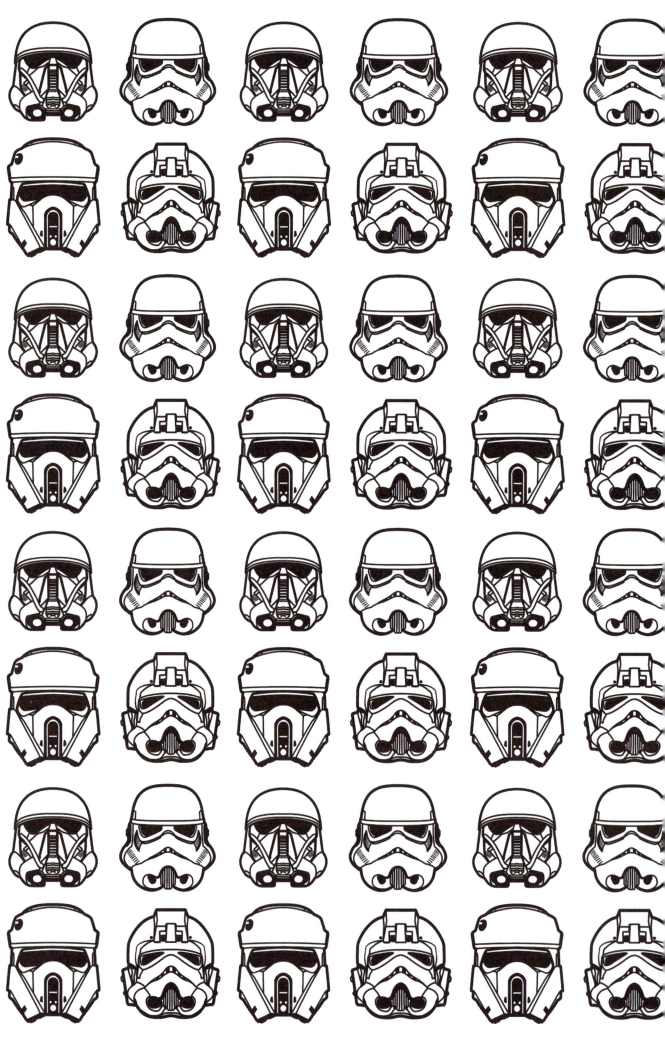

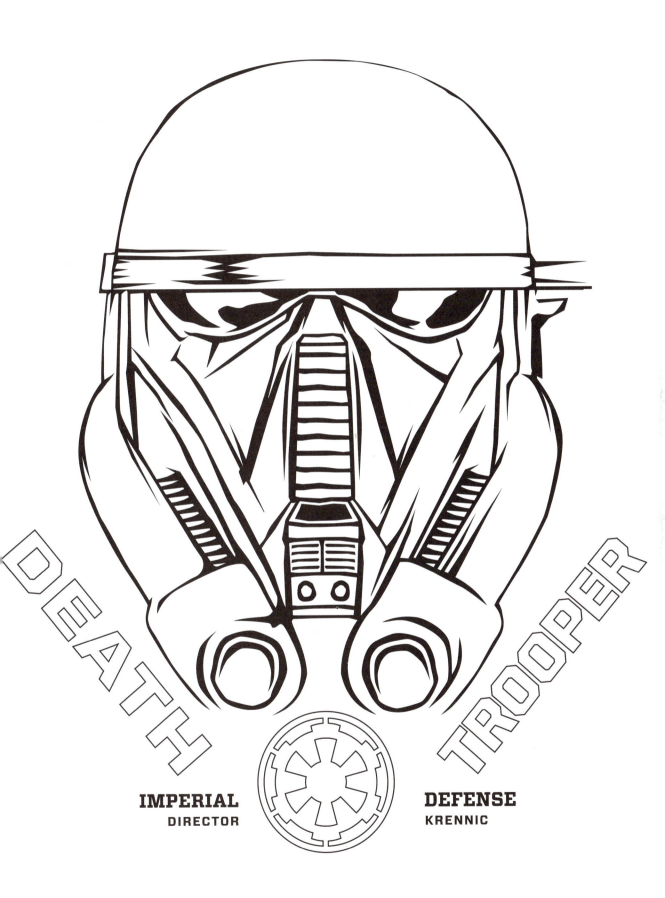

DEATH TROOPER

IMPERIAL
DIRECTOR

DEFENSE
KRENNIC

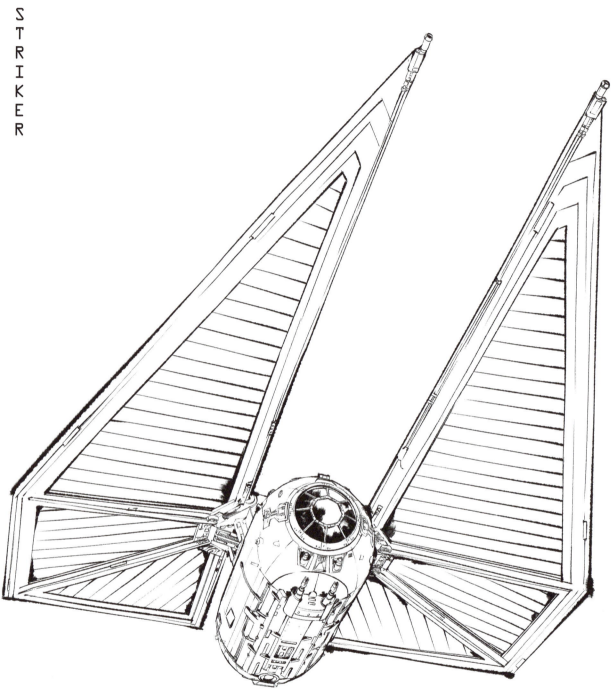

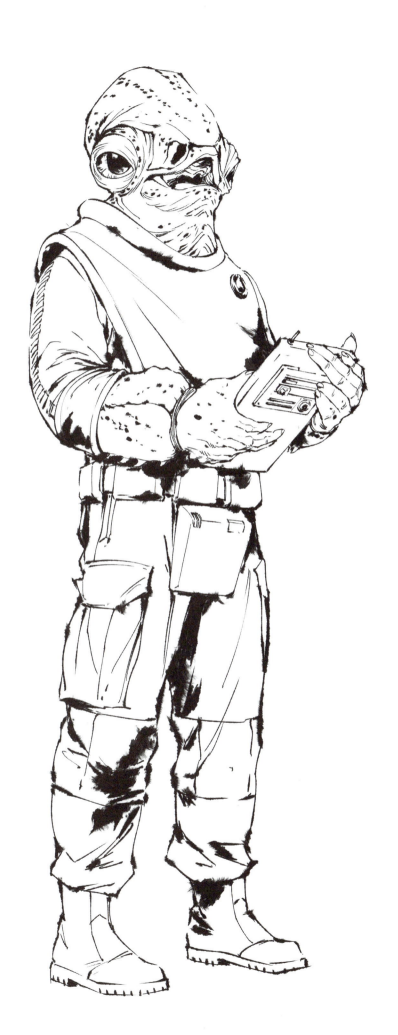

LT SHOLLAN

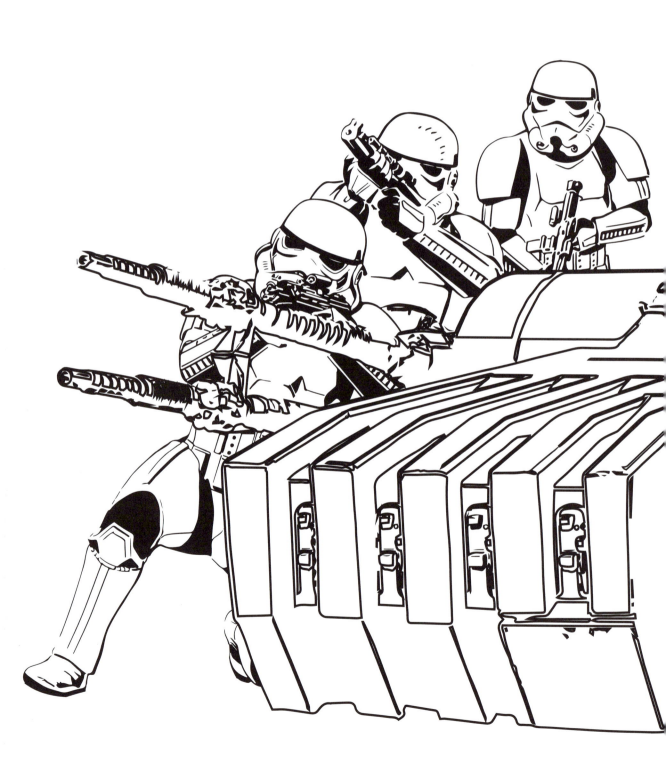

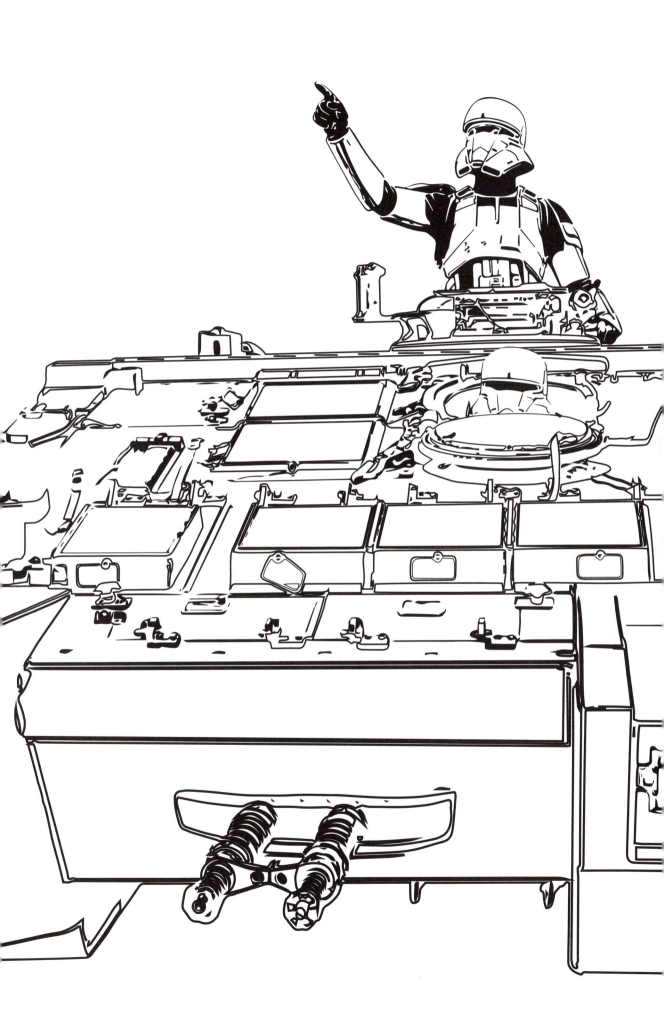

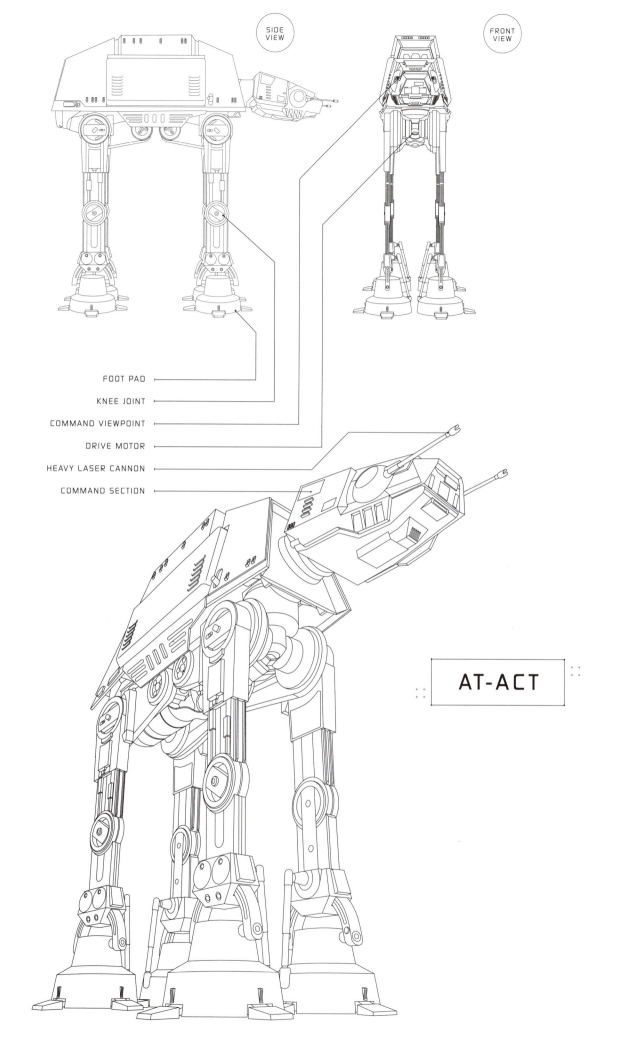

SIDE VIEW

FRONT VIEW

FOOT PAD

KNEE JOINT

COMMAND VIEWPOINT

DRIVE MOTOR

HEAVY LASER CANNON

COMMAND SECTION

AT-ACT

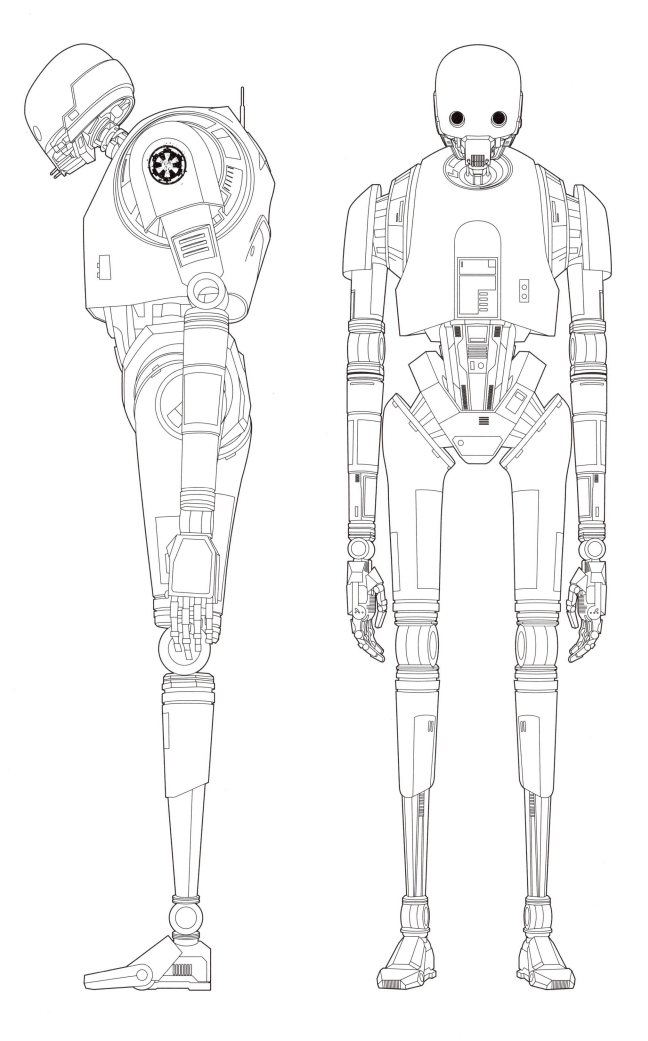

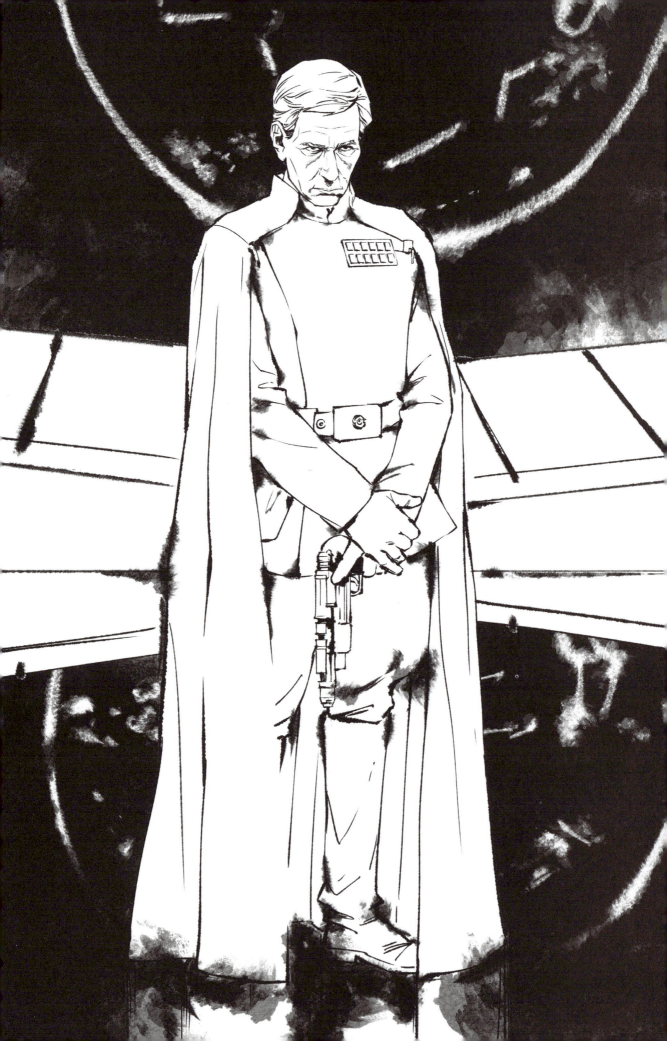

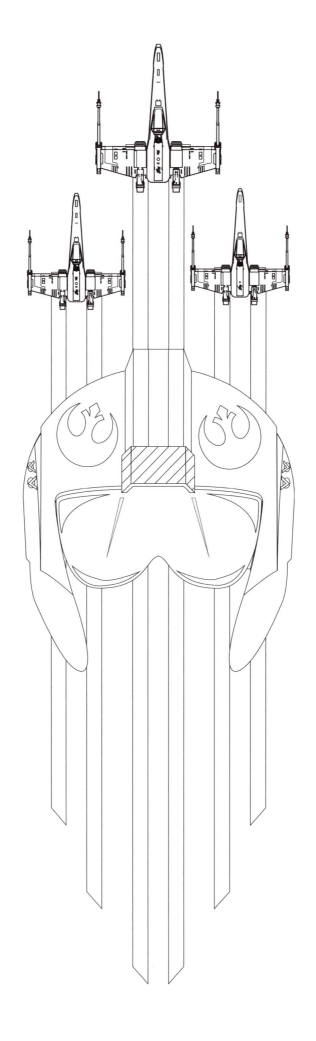

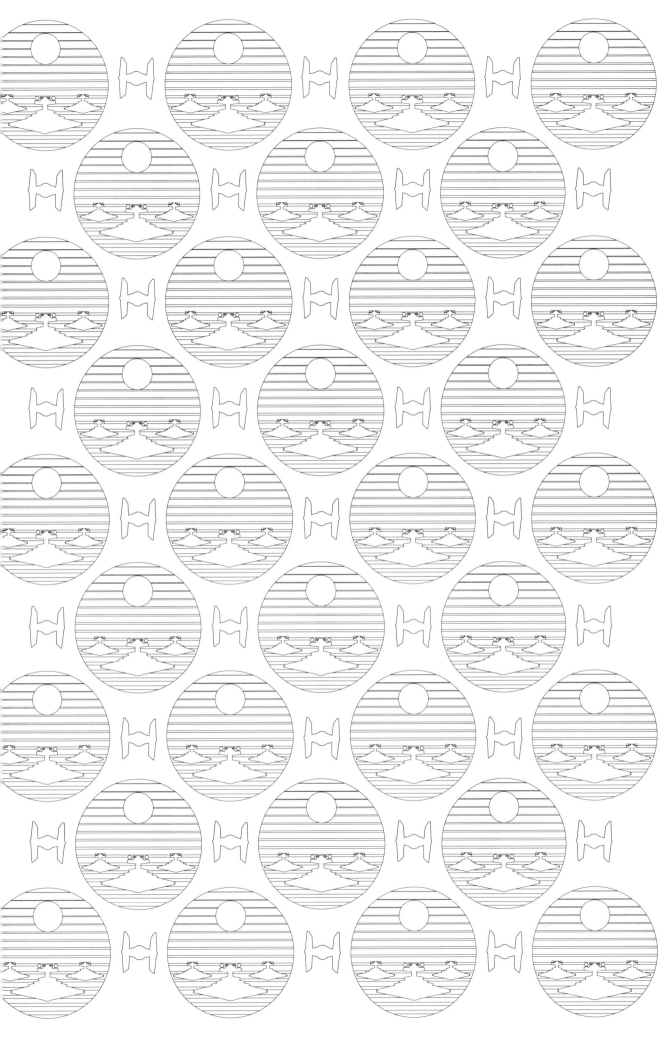

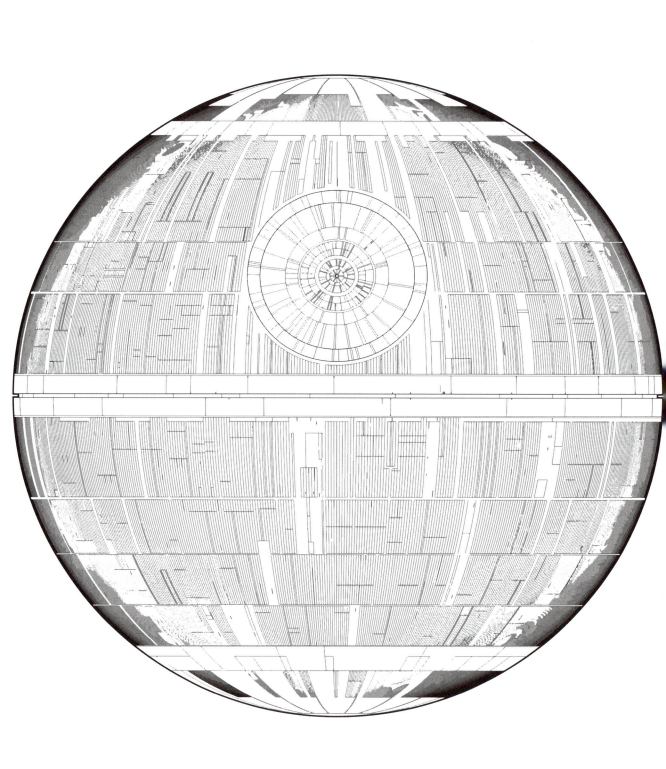

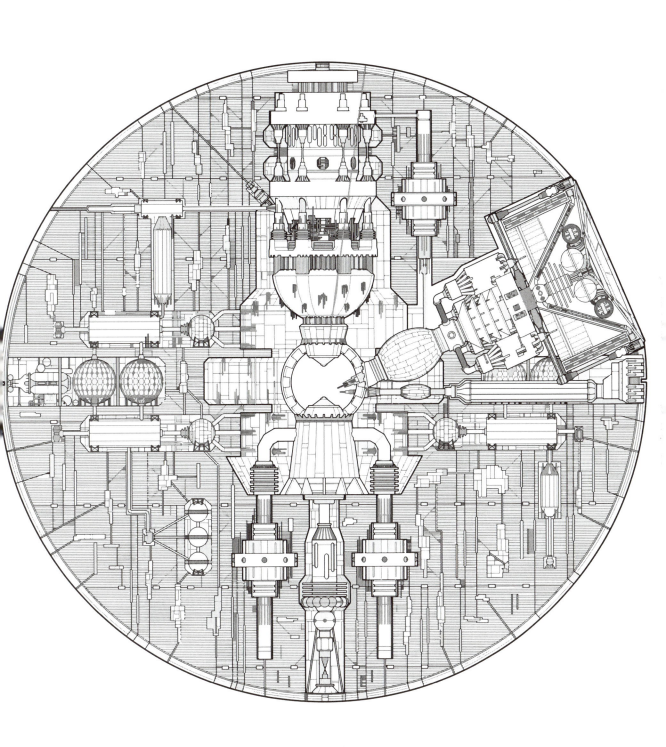

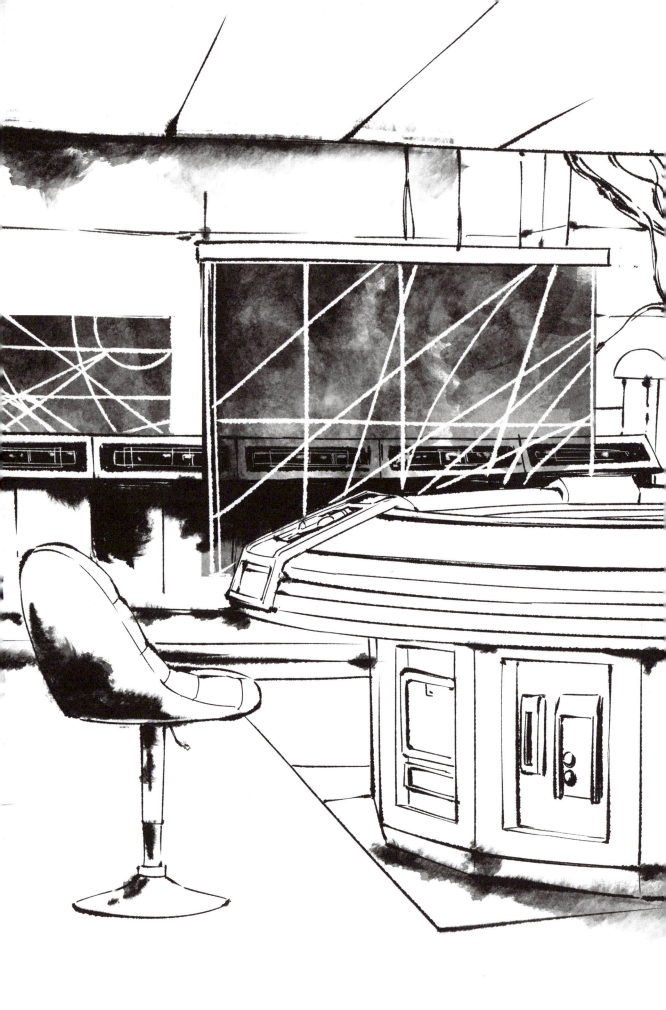

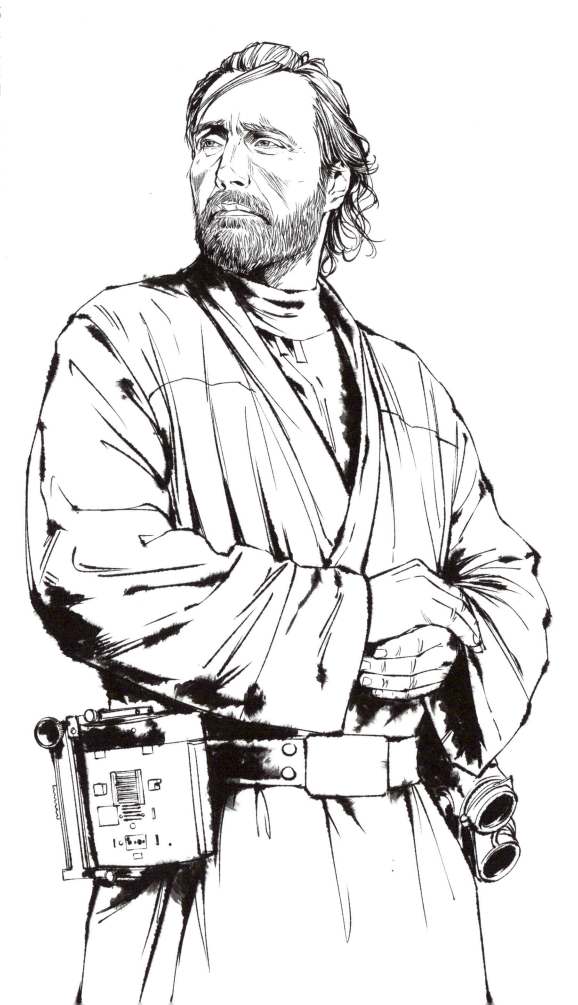

GALEN ERSO

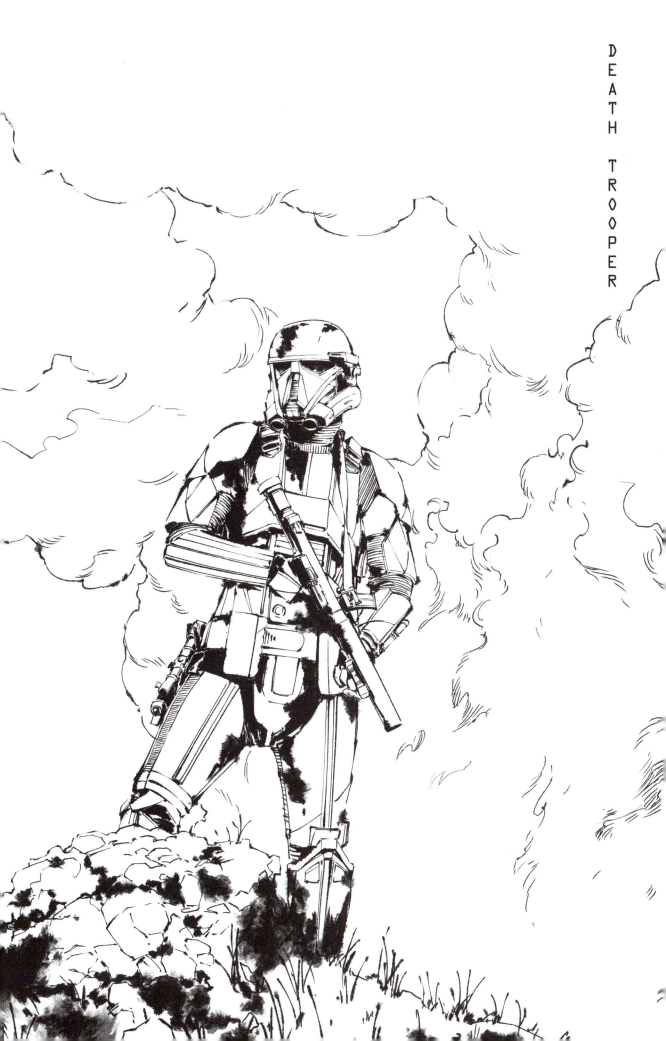

DEATH TROOPER

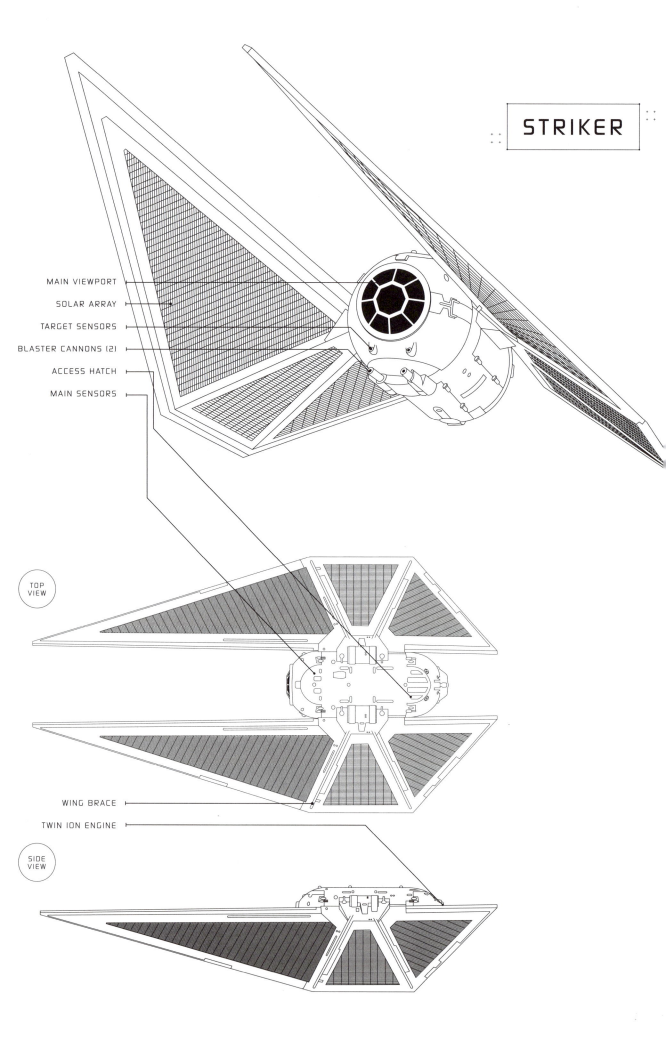

STRIKER

MAIN VIEWPORT

SOLAR ARRAY

TARGET SENSORS

BLASTER CANNONS (2)

ACCESS HATCH

MAIN SENSORS

TOP
VIEW

WING BRACE

TWIN ION ENGINE

SIDE
VIEW

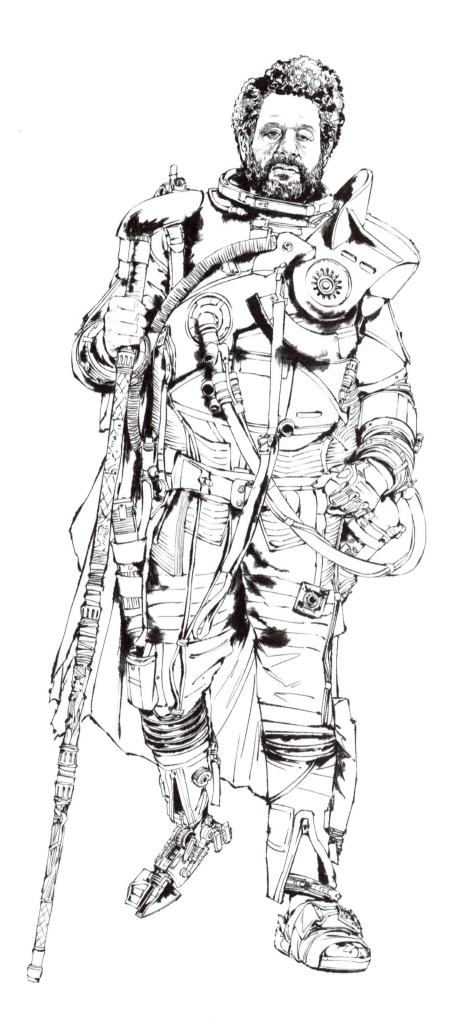

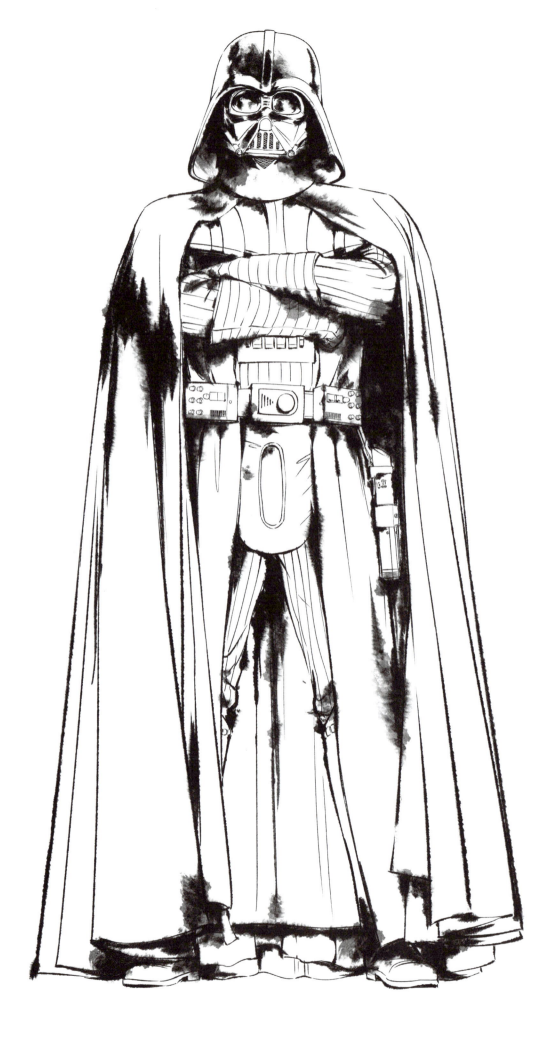

DARTH VADER

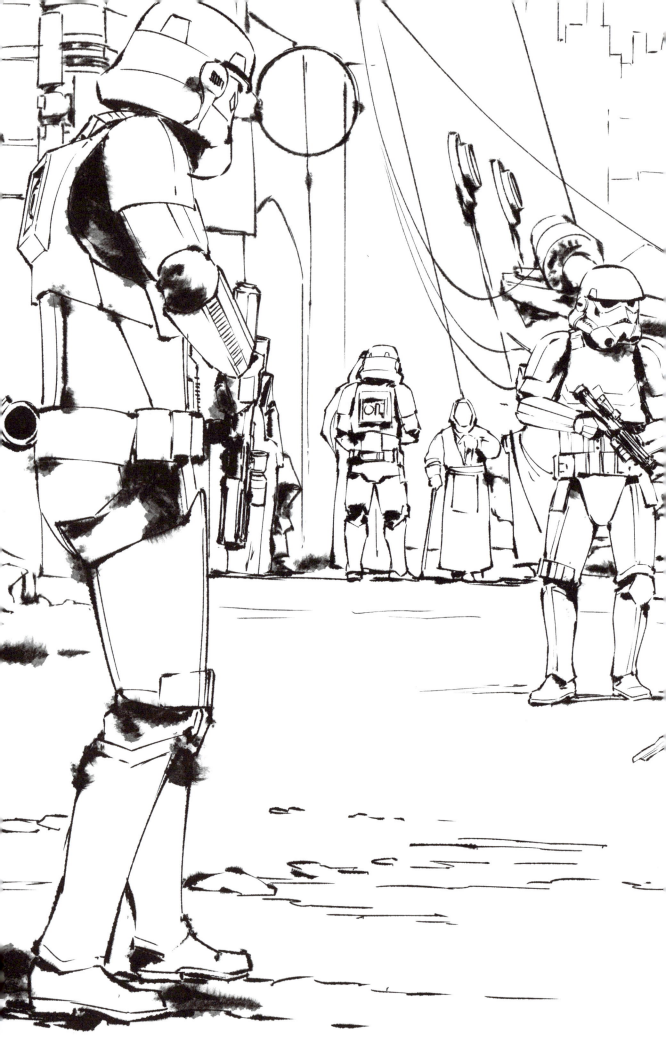

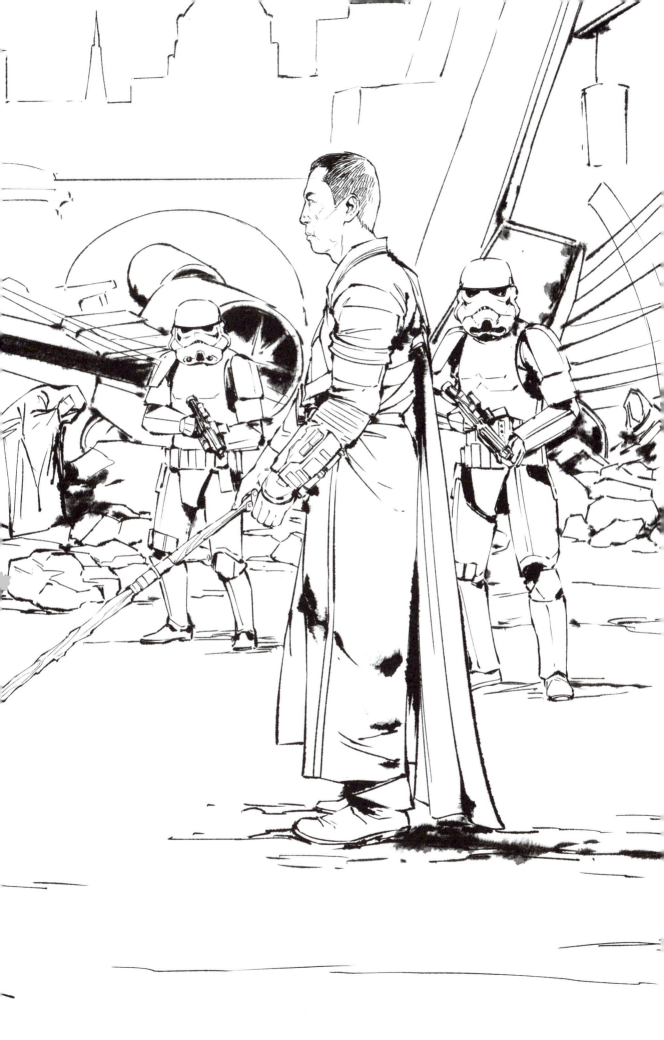

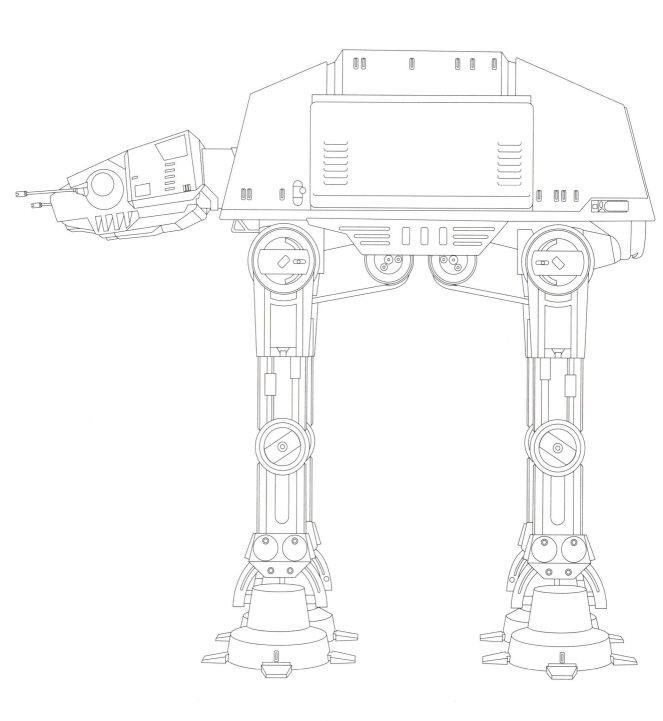

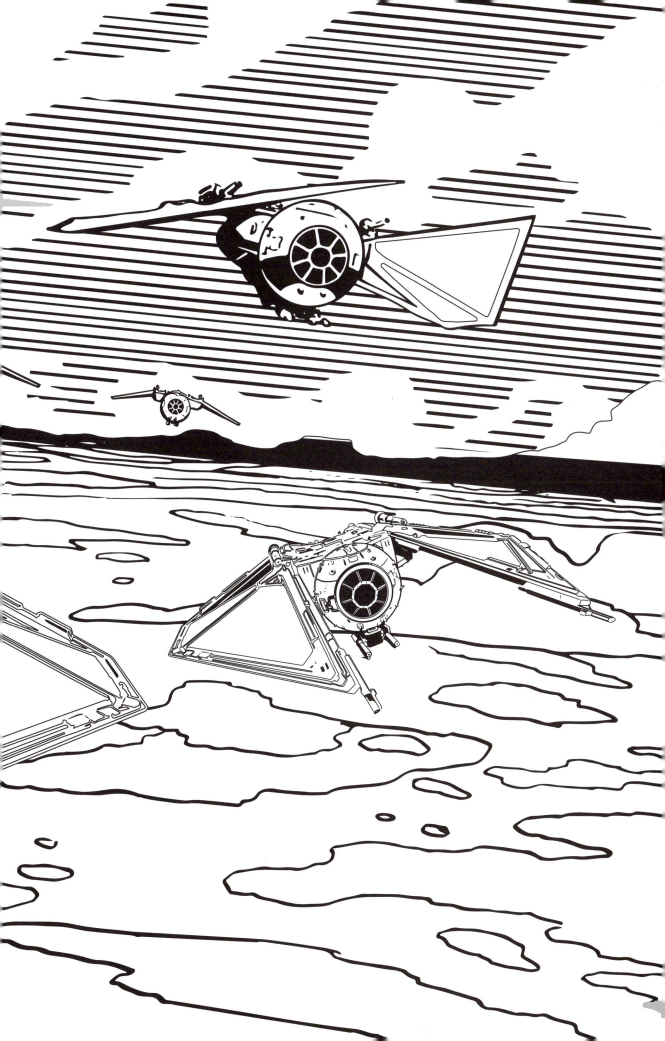

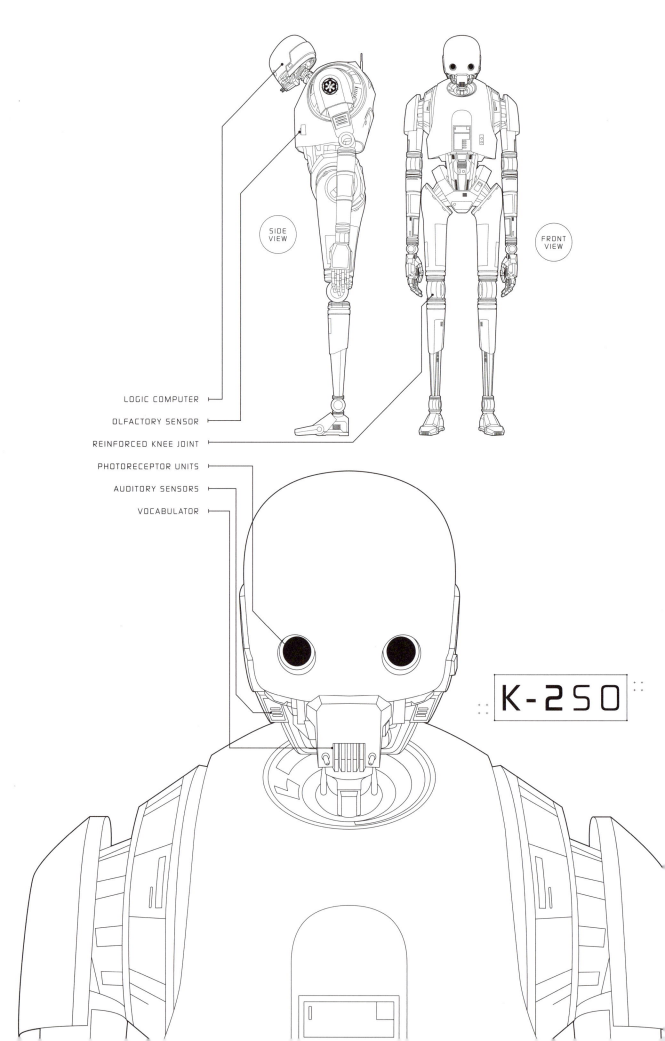

SIDE
VIEW

FRONT
VIEW

LOGIC COMPUTER

OLFACTORY SENSOR

REINFORCED KNEE JOINT

PHOTORECEPTOR UNITS

AUDITORY SENSORS

VOCABULATOR

K-2SO

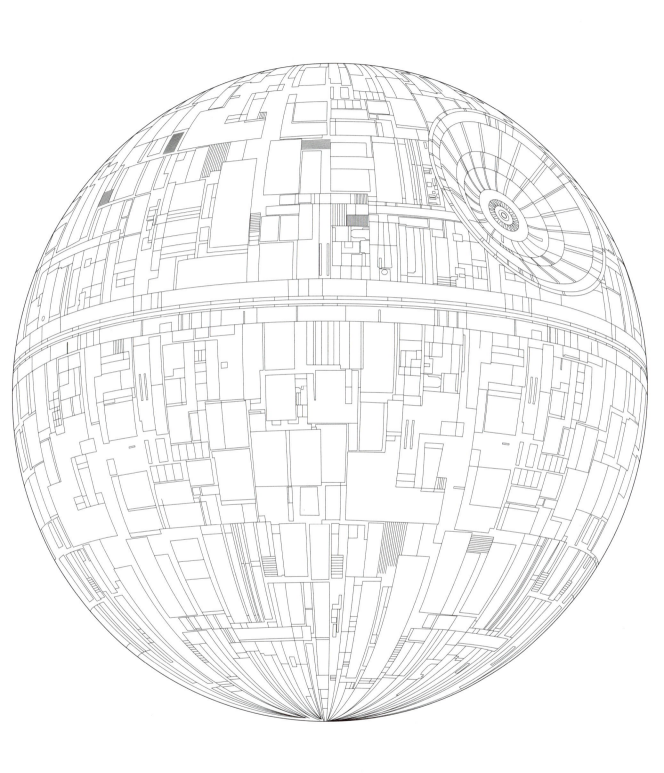

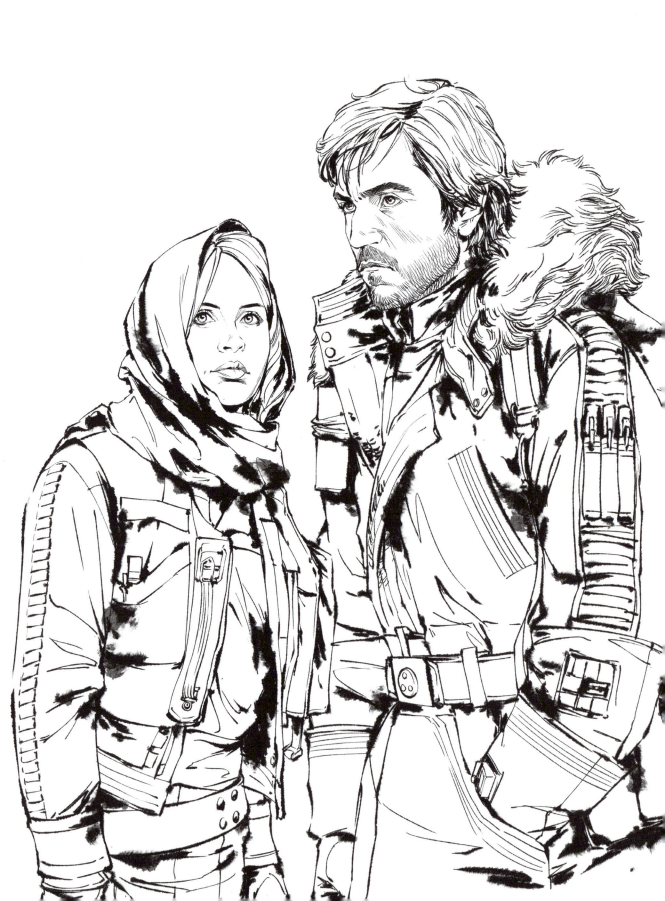

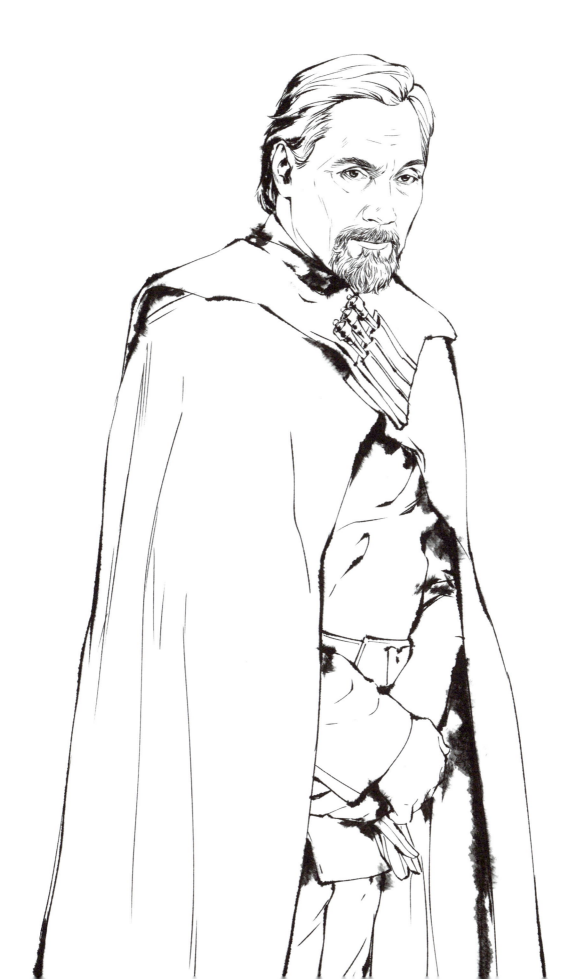

BAIL ORGANA

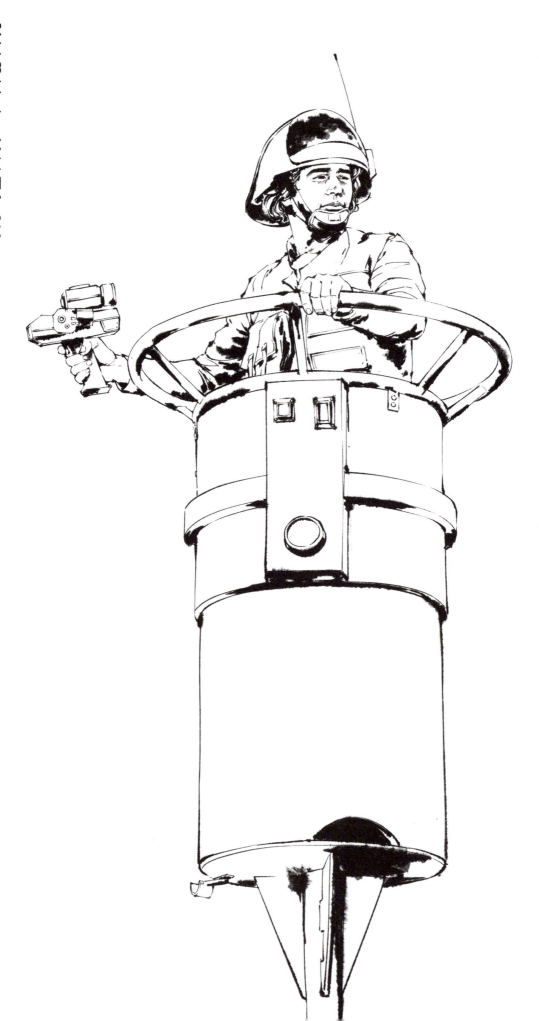

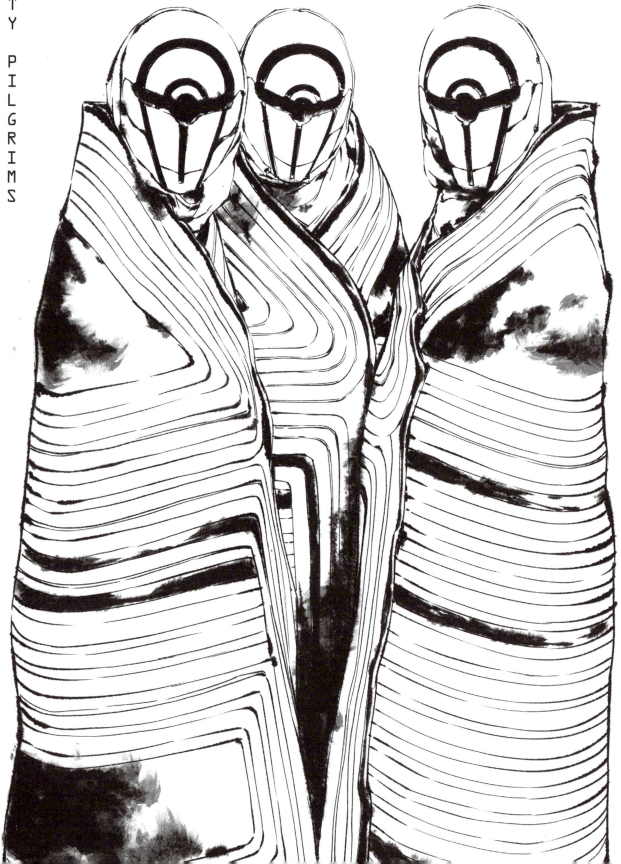

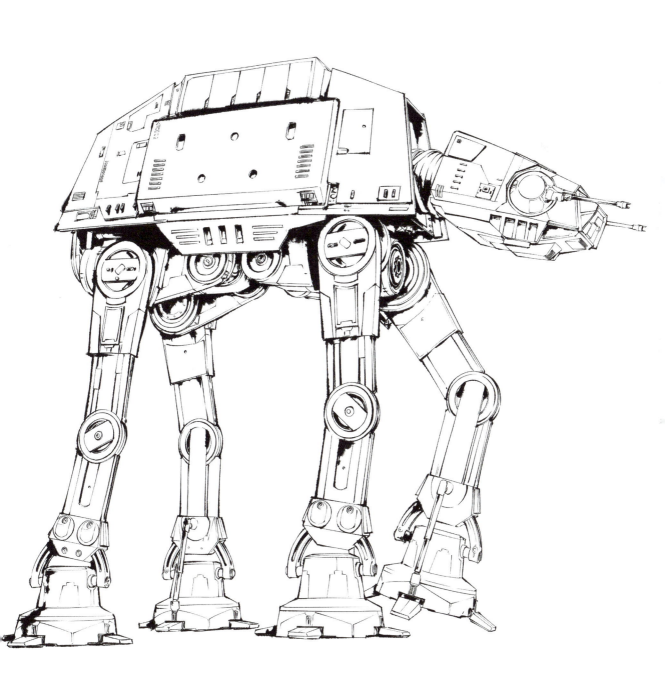

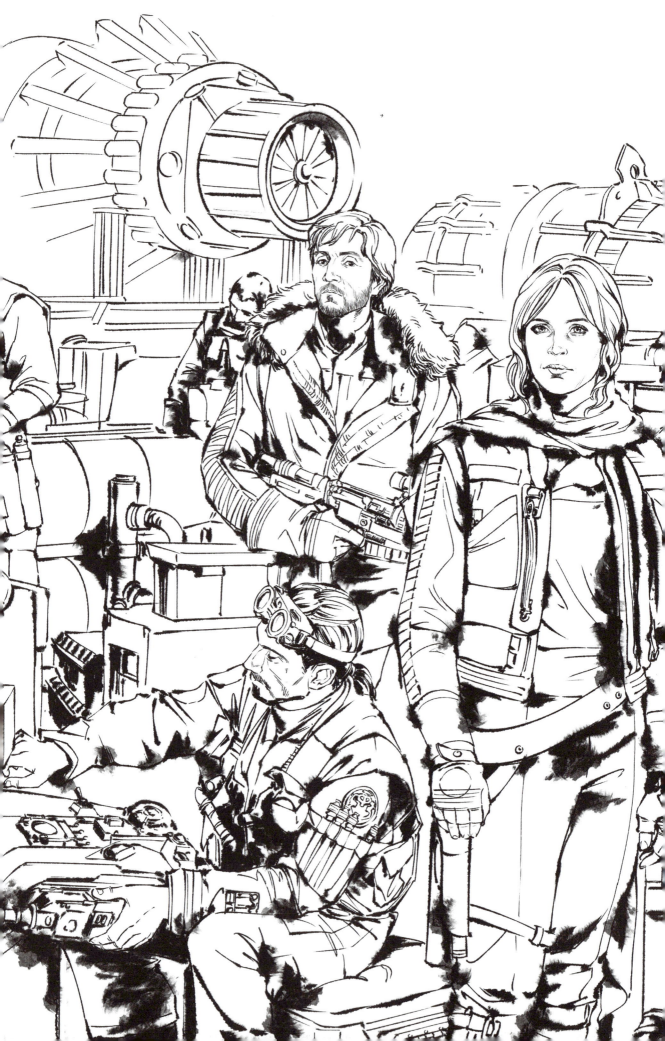

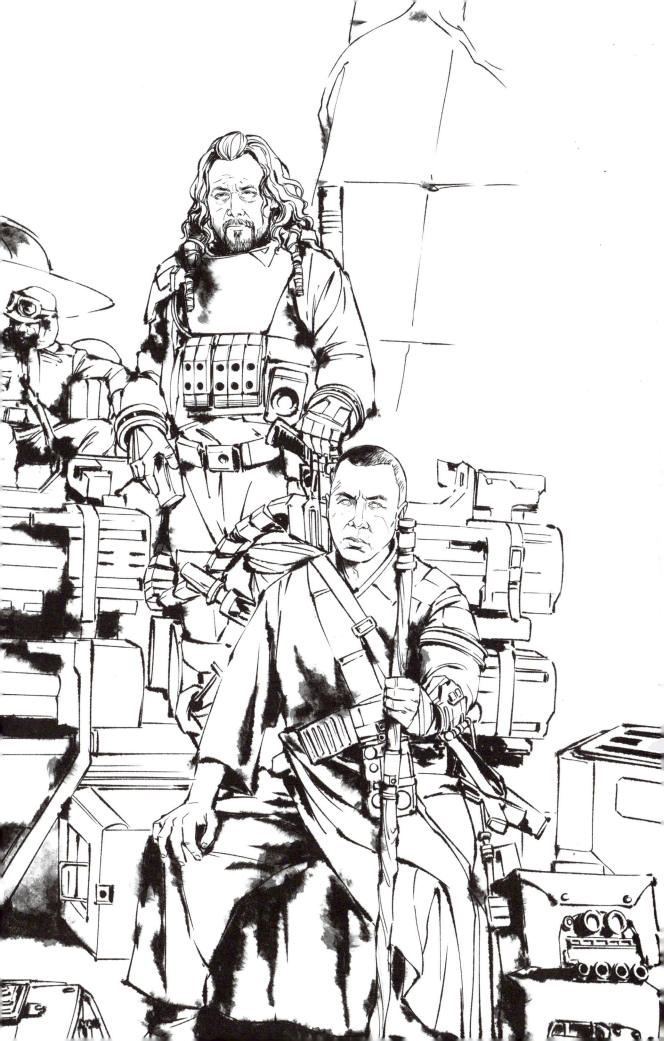

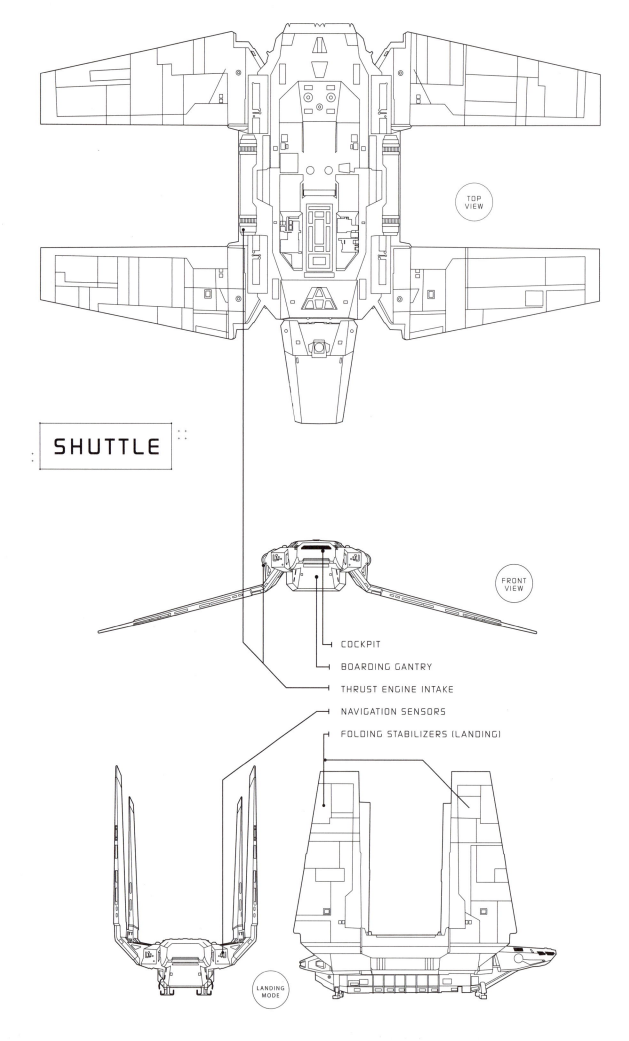

SHUTTLE

TOP VIEW

FRONT VIEW

COCKPIT

BOARDING GANTRY

THRUST ENGINE INTAKE

NAVIGATION SENSORS

FOLDING STABILIZERS (LANDING)

LANDING MODE

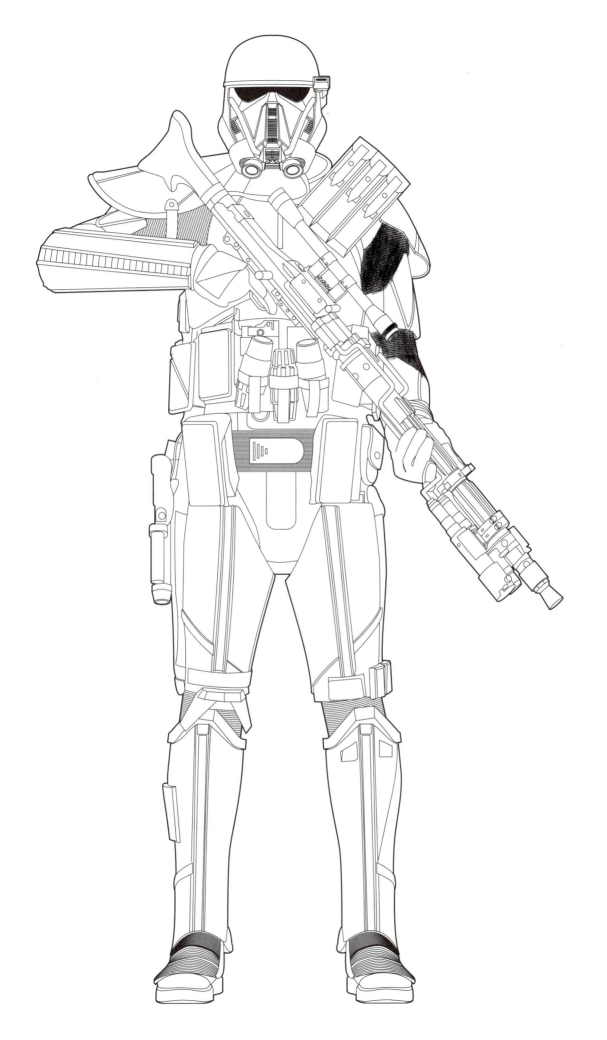

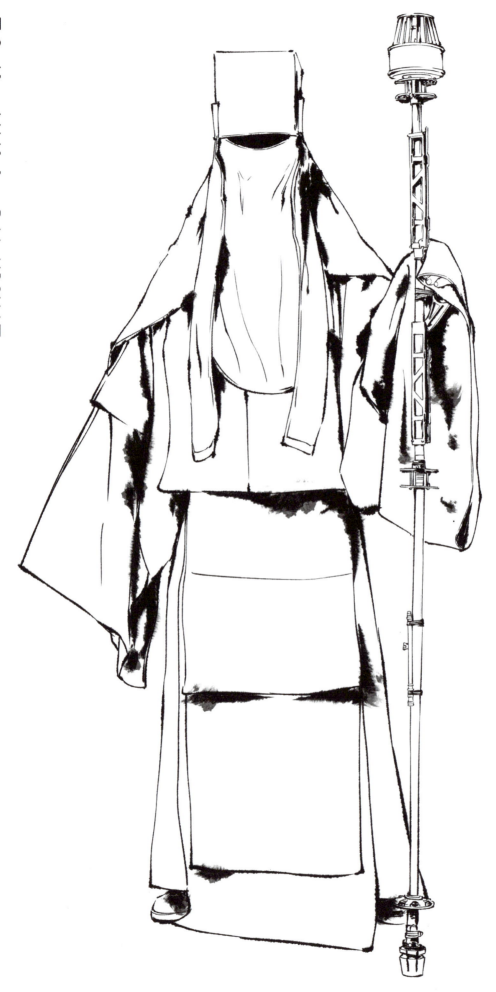

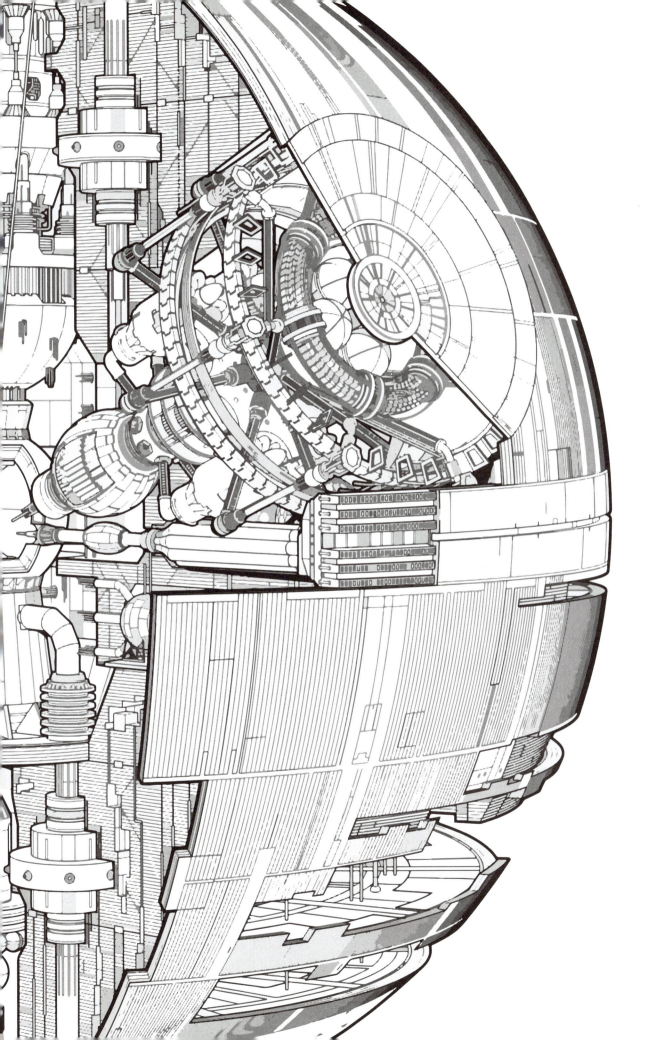

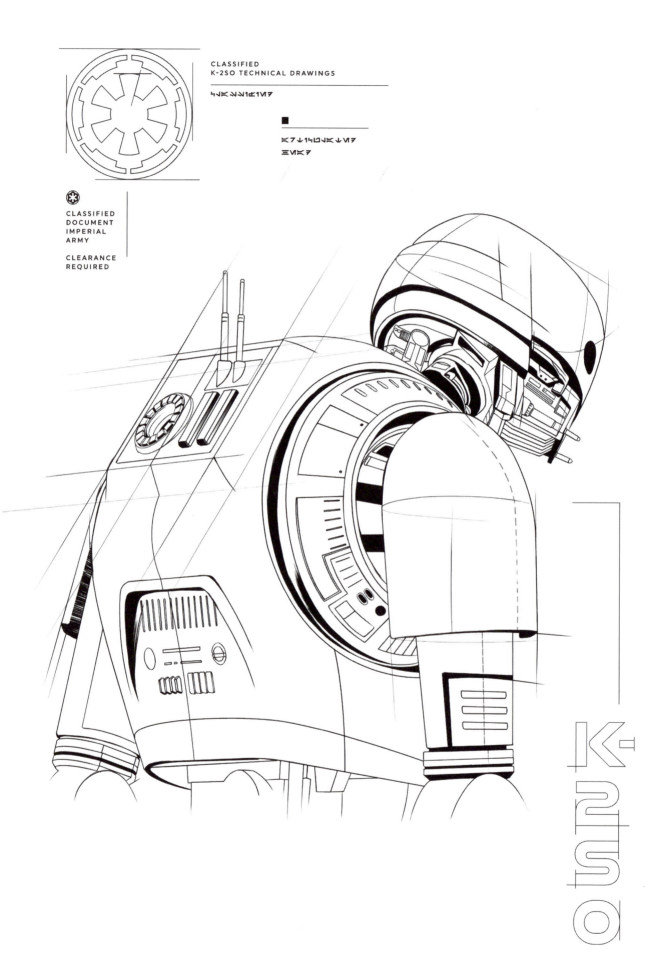

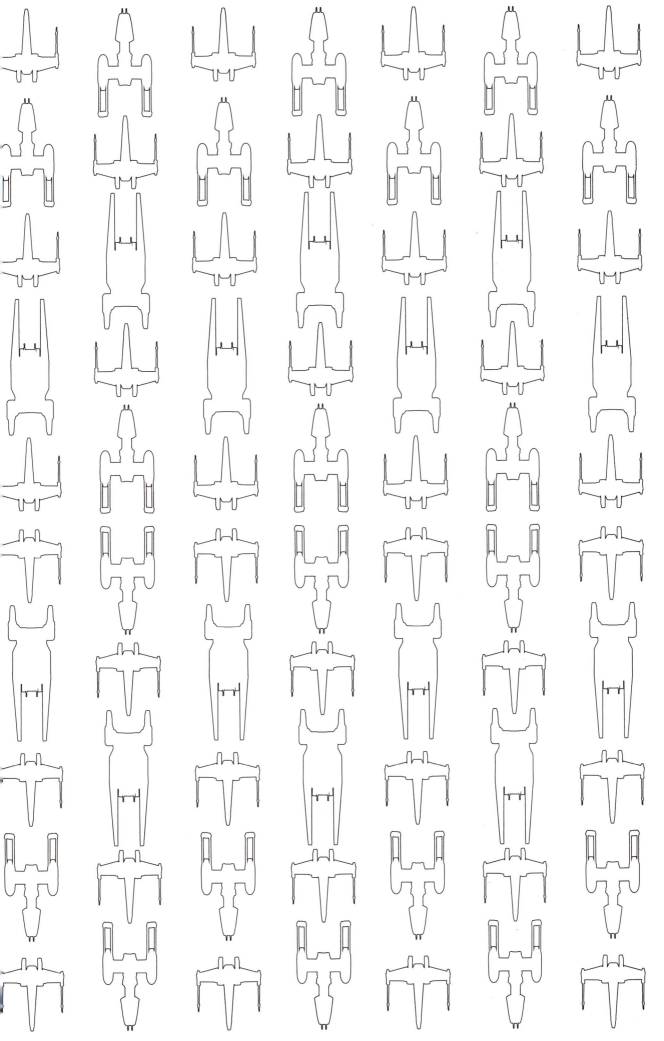

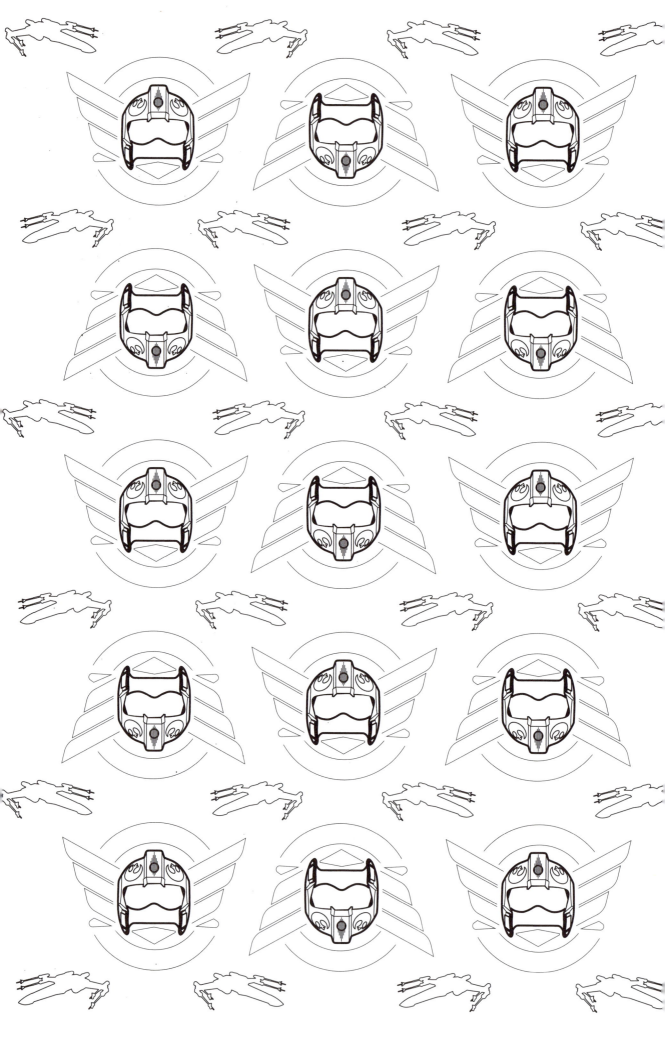

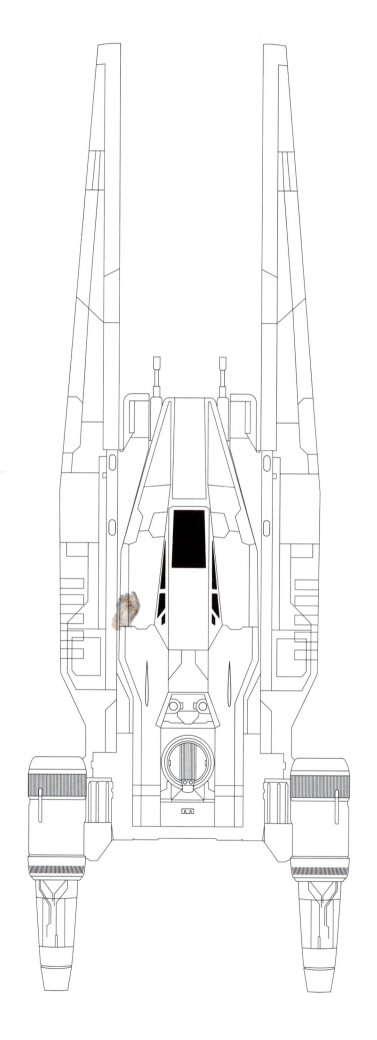

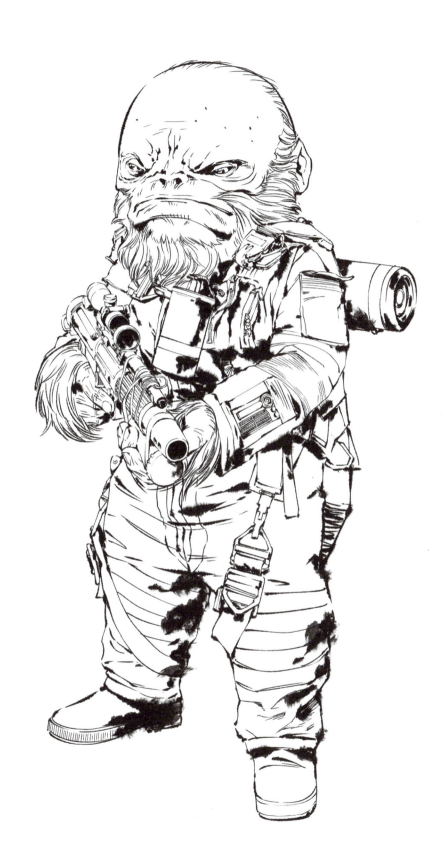

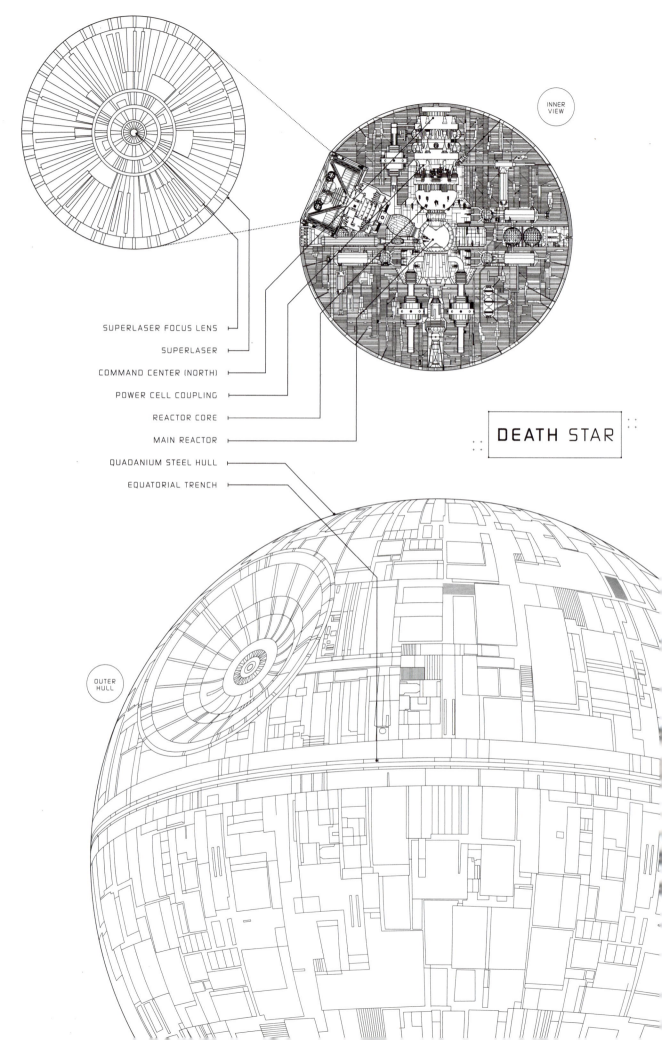

INNER
VIEW

SUPERLASER FOCUS LENS ⊢

SUPERLASER ⊢

COMMAND CENTER (NORTH) ⊢

POWER CELL COUPLING ⊢

REACTOR CORE ⊢

MAIN REACTOR ⊢

QUADANIUM STEEL HULL ⊢

EQUATORIAL TRENCH ⊢

DEATH STAR

OUTER
HULL

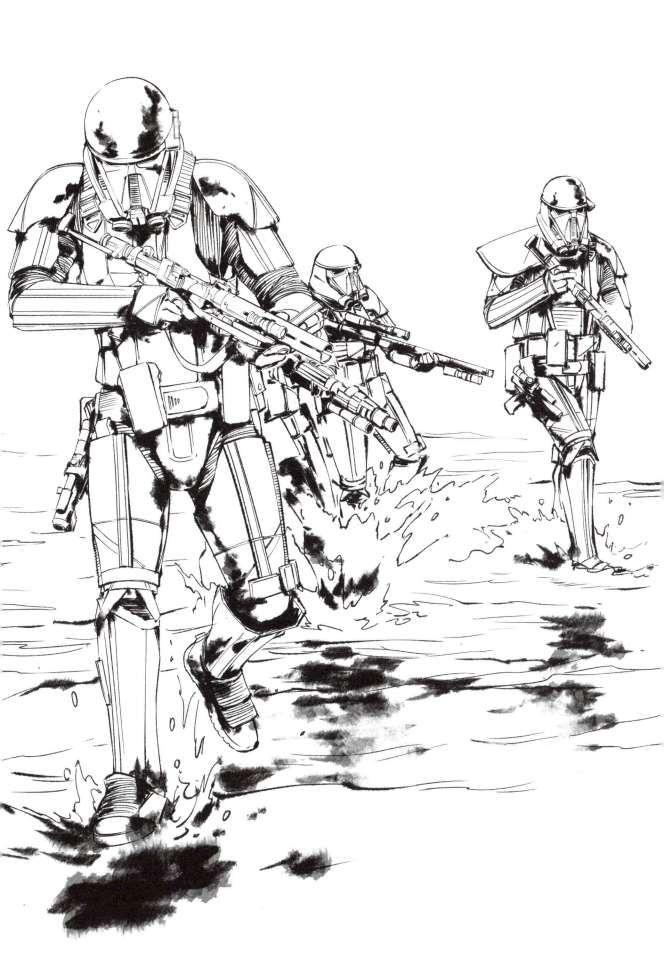

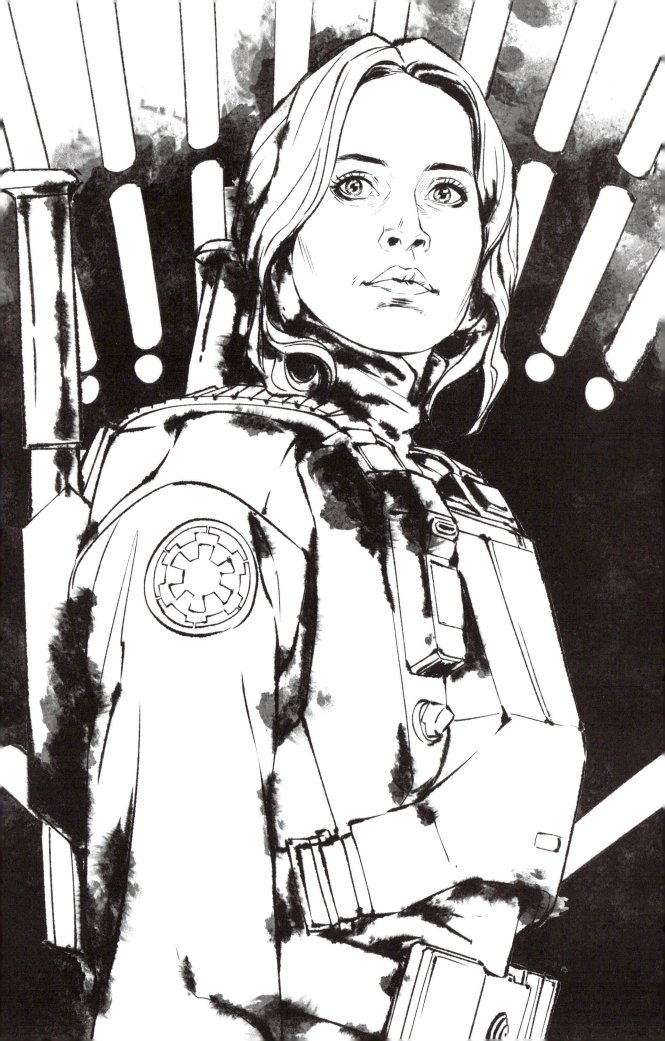

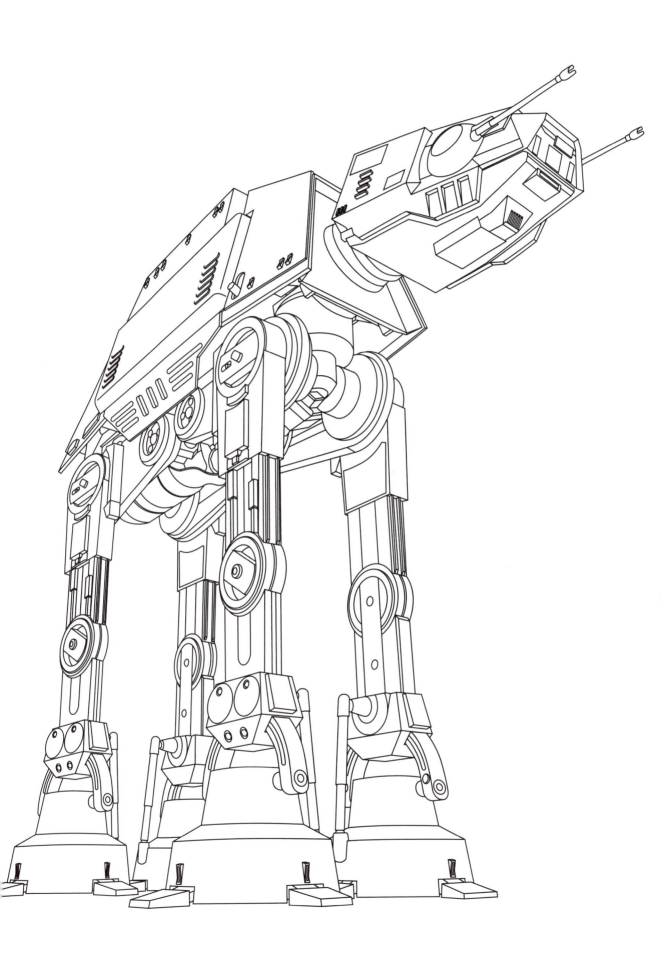

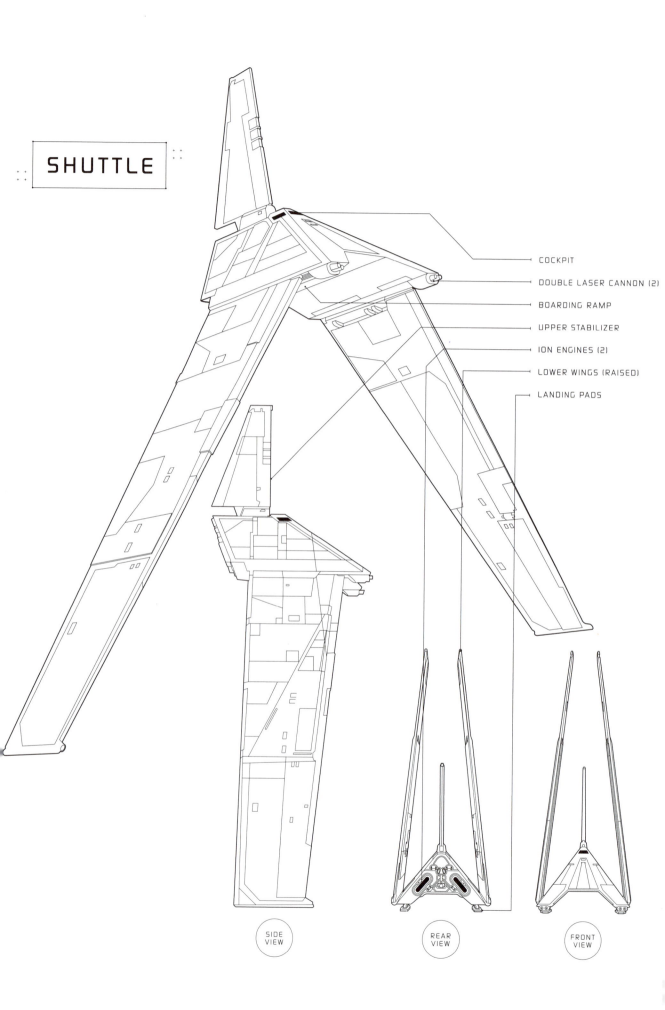

SHUTTLE

COCKPIT

DOUBLE LASER CANNON (2)

BOARDING RAMP

UPPER STABILIZER

ION ENGINES (2)

LOWER WINGS (RAISED)

LANDING PADS

SIDE
VIEW

REAR
VIEW

FRONT
VIEW

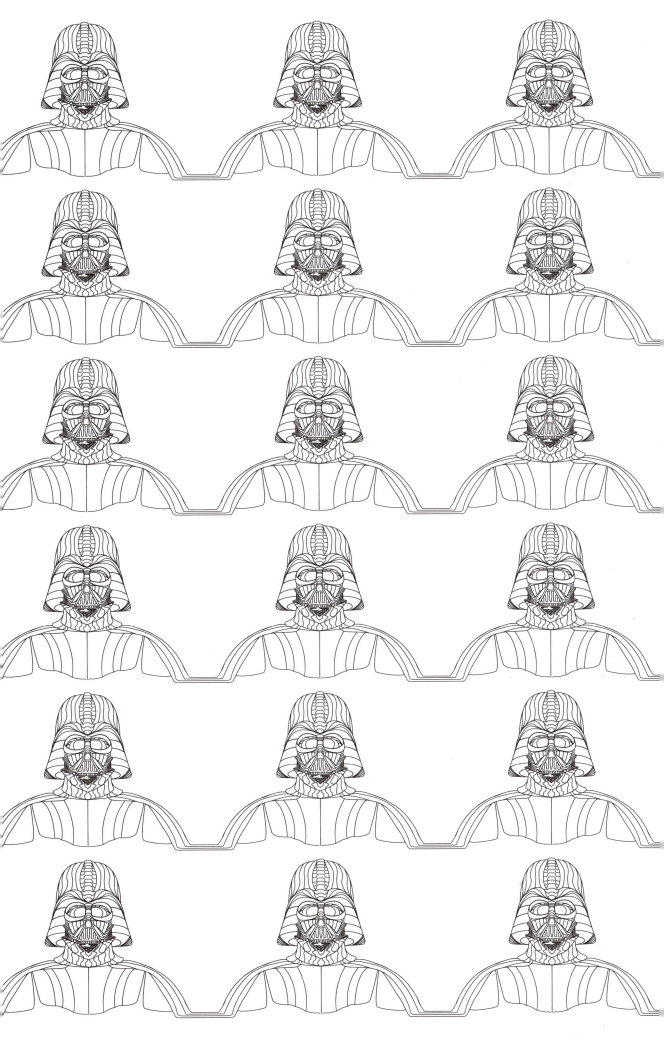

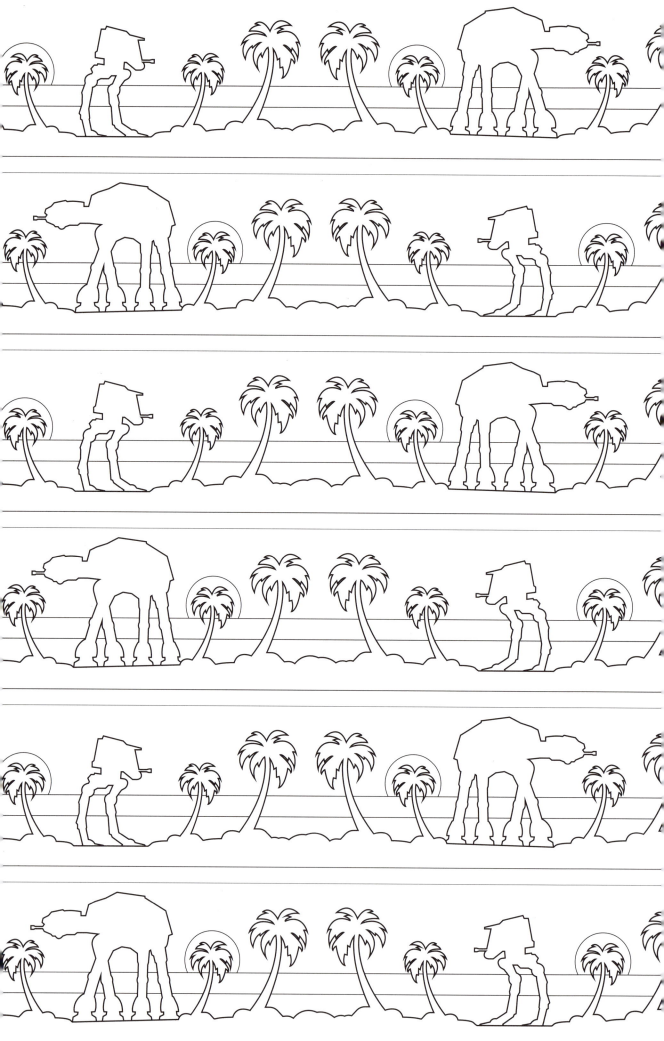

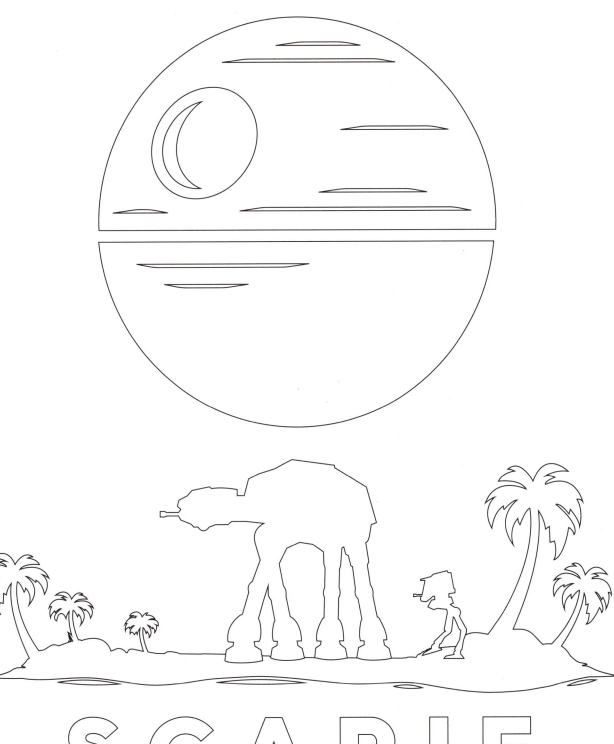

SCARIF

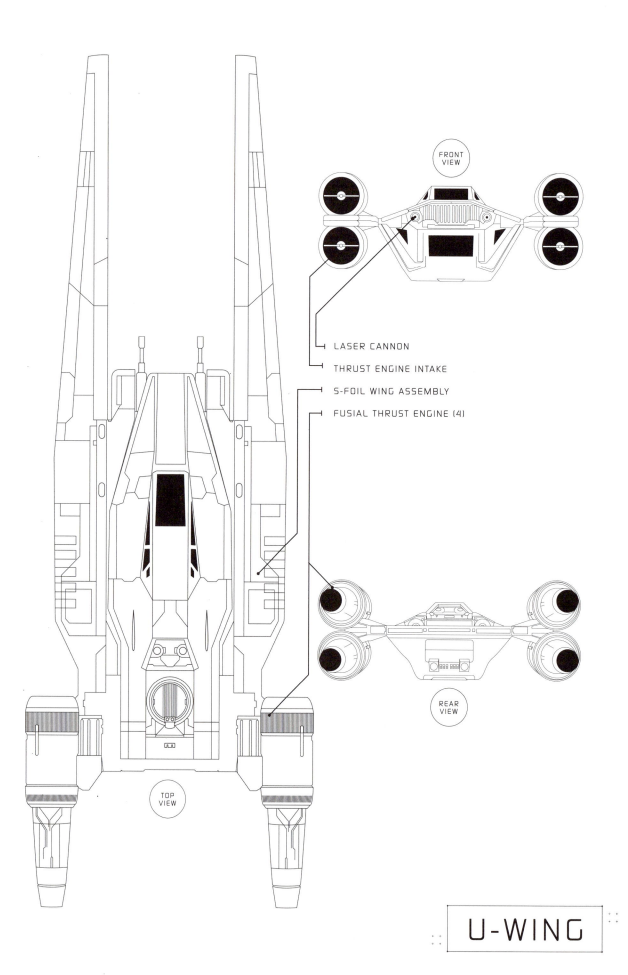

FRONT
VIEW

LASER CANNON

THRUST ENGINE INTAKE

S-FOIL WING ASSEMBLY

FUSIAL THRUST ENGINE (4)

REAR
VIEW

TOP
VIEW

U-WING

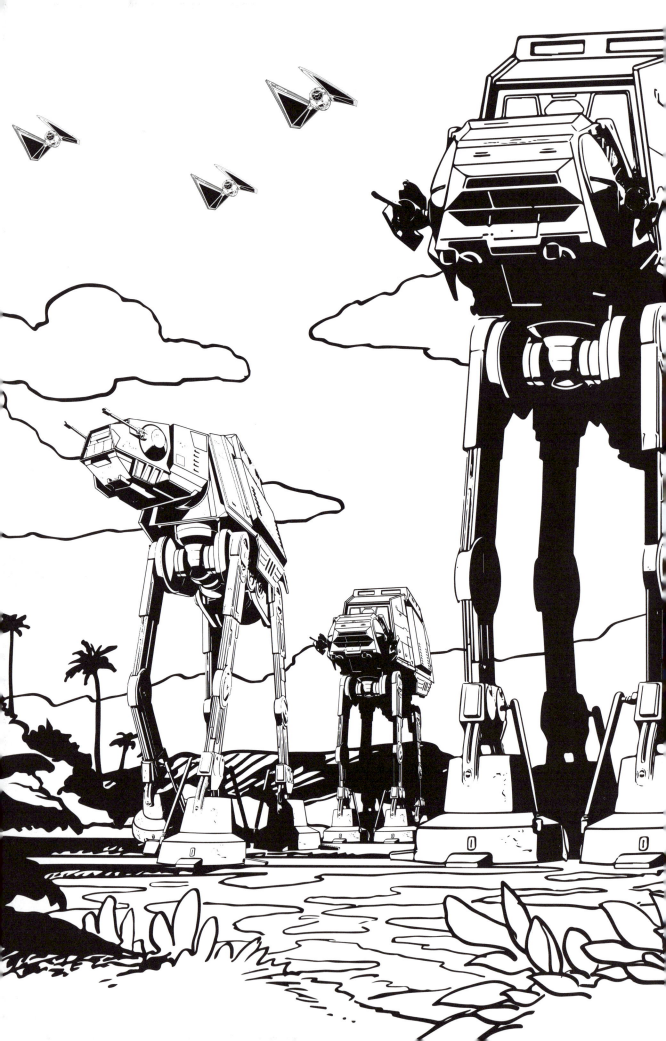

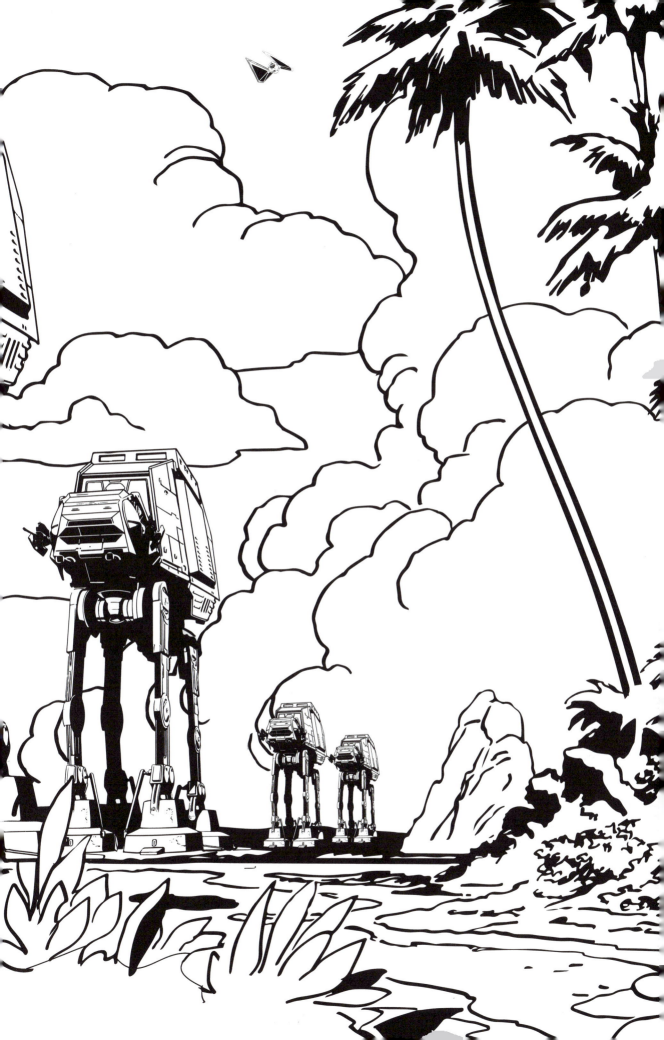

BISTAN

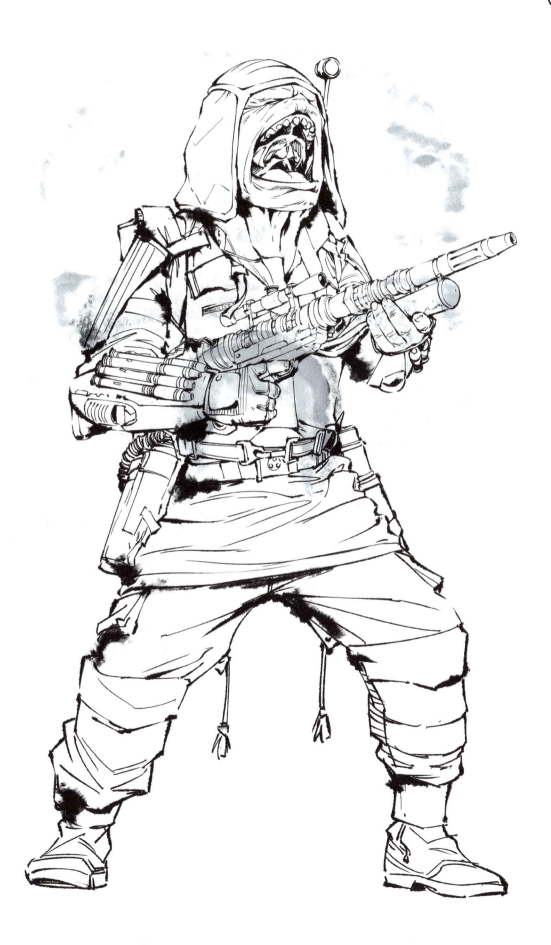

PAO

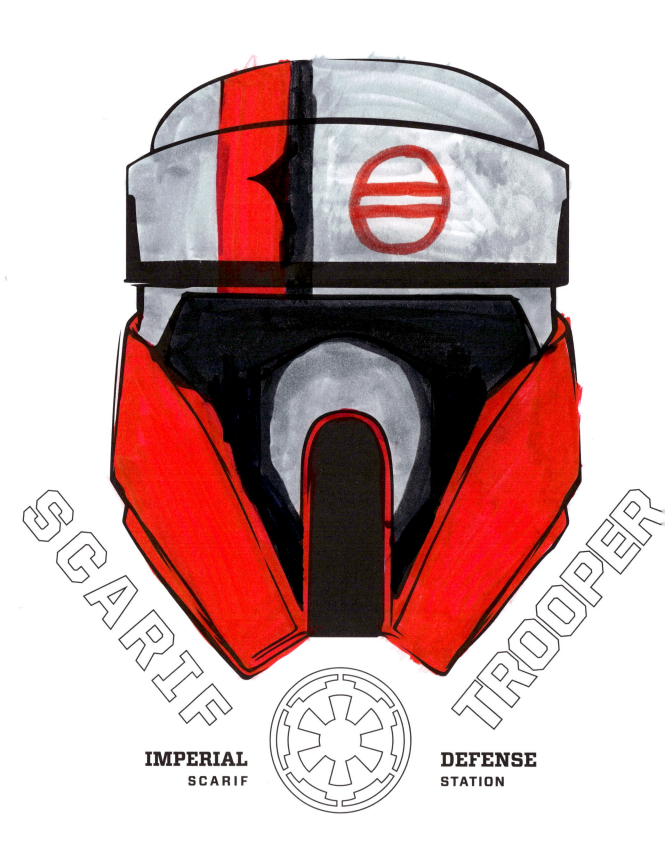

SCARIF

TROOPER

IMPERIAL

SCARIF

DEFENSE

STATION

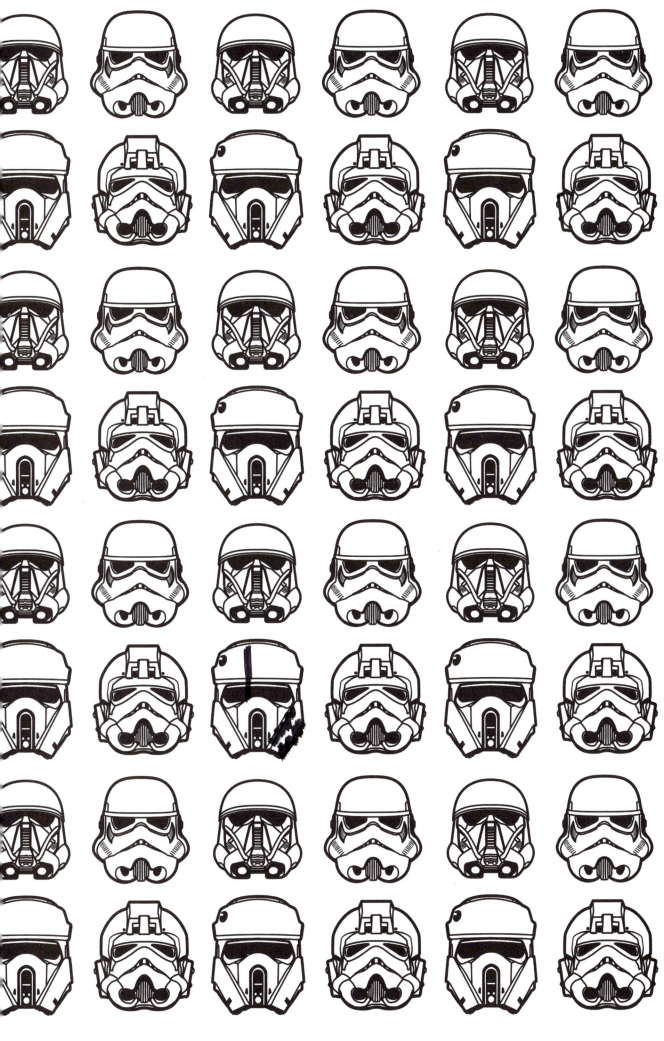

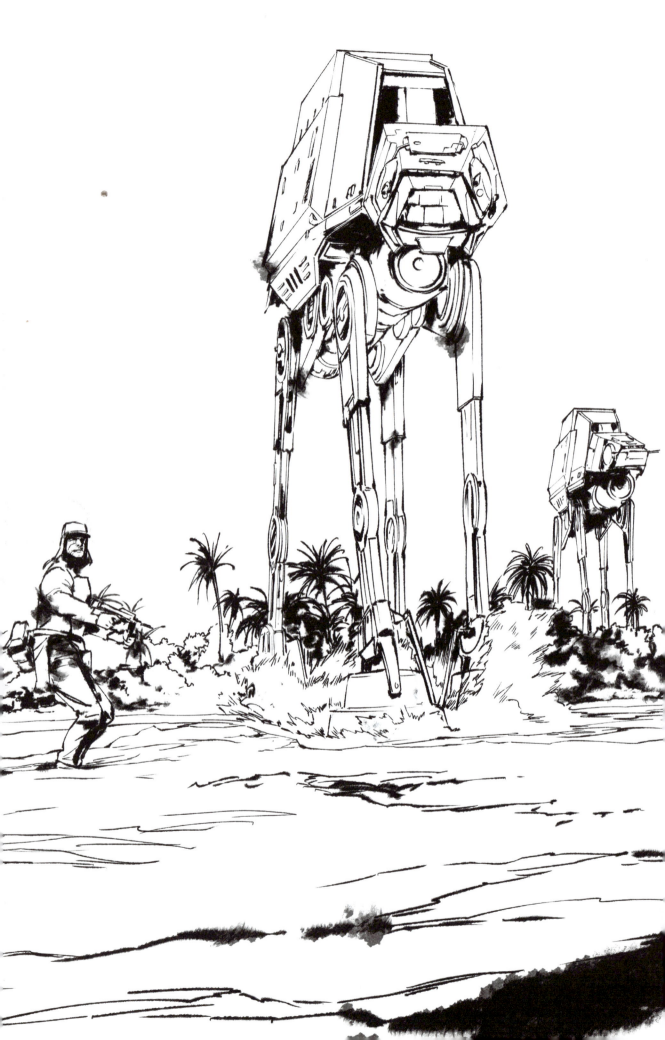

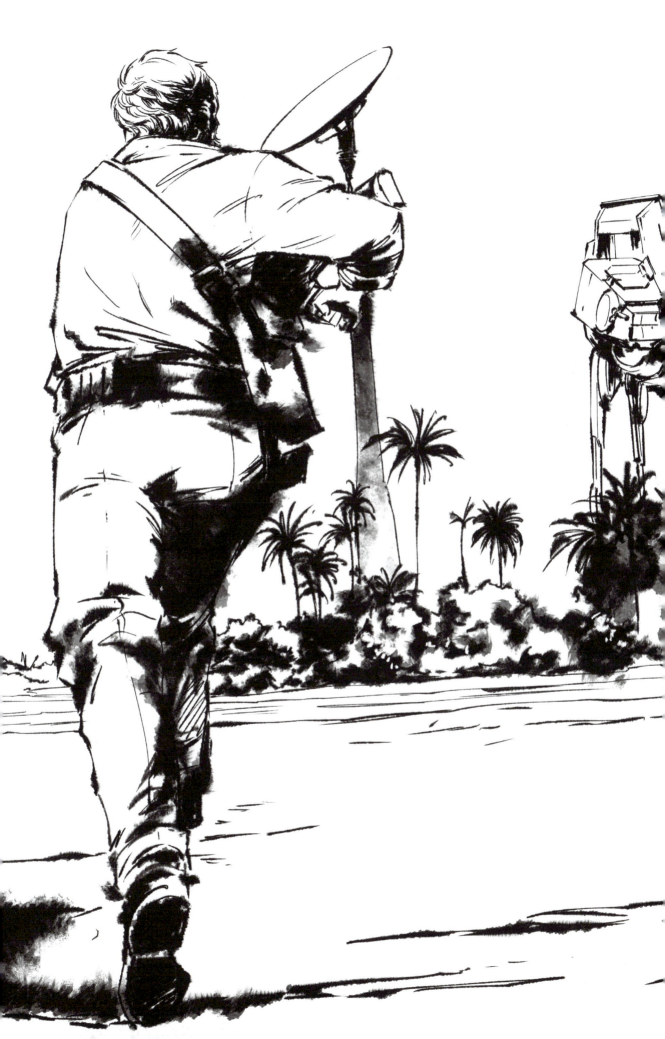

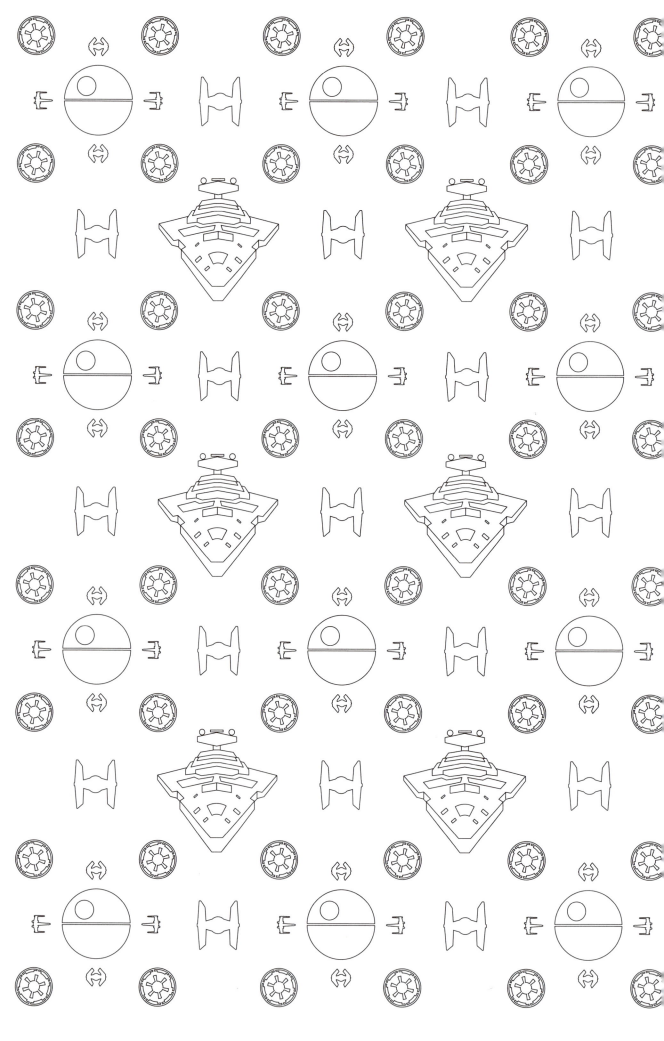

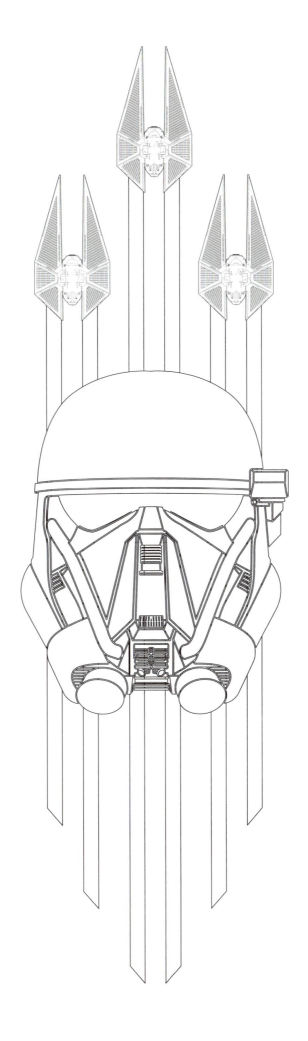

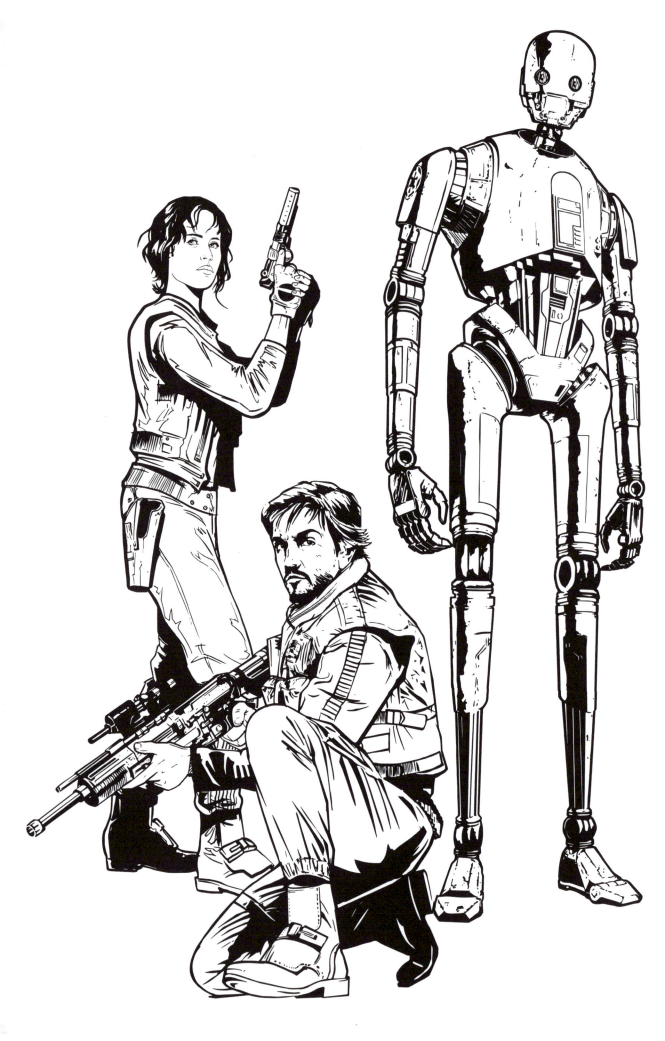

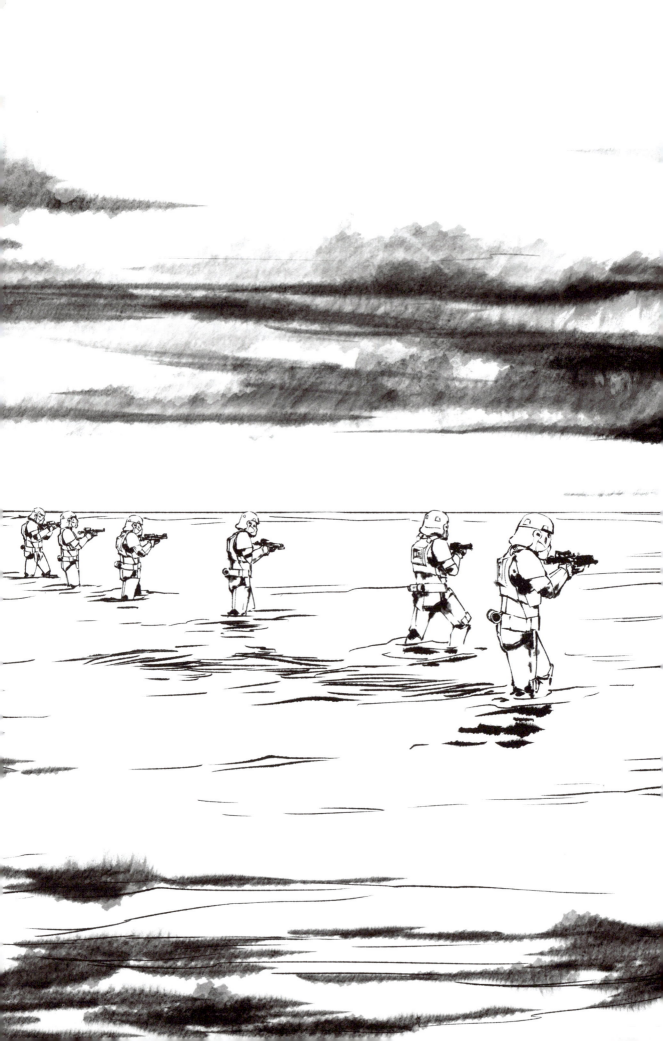

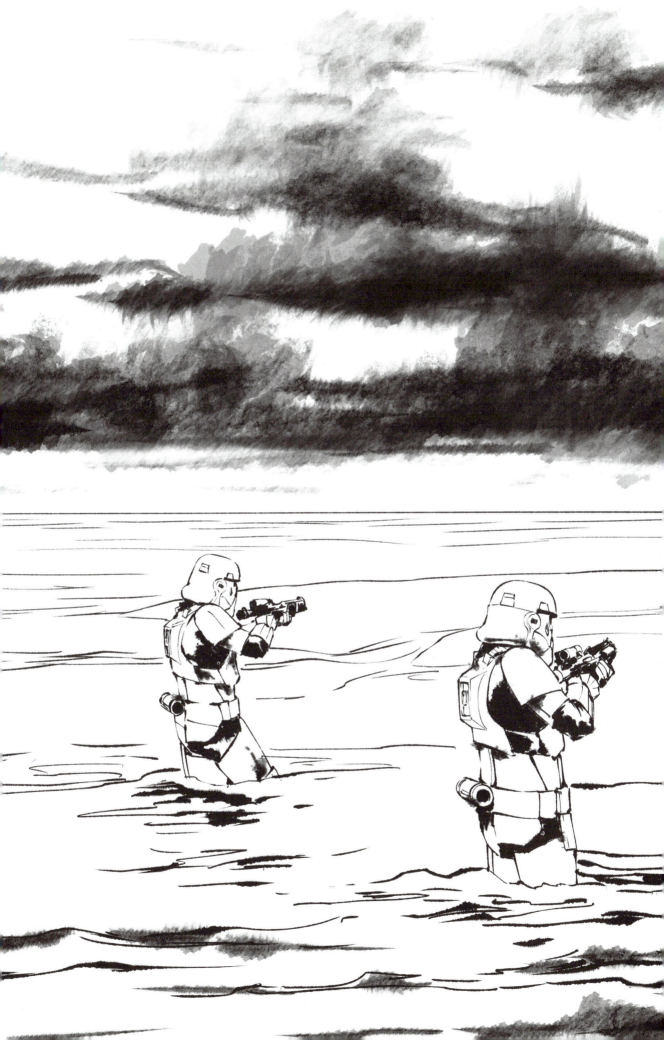

Printed in the United States of America

First Edition, December 2016

1 3 5 7 9 10 8 6 4 2

Library of Congress Control Number on file

FAC-014353-16309

ISBN 978-1-4847-9864-5

Los Angeles • New York

Certified Chain of Custody
35% Certified Forest Content,
65% Certified Sourcing
www.sfiprogram.org
SFI-00993

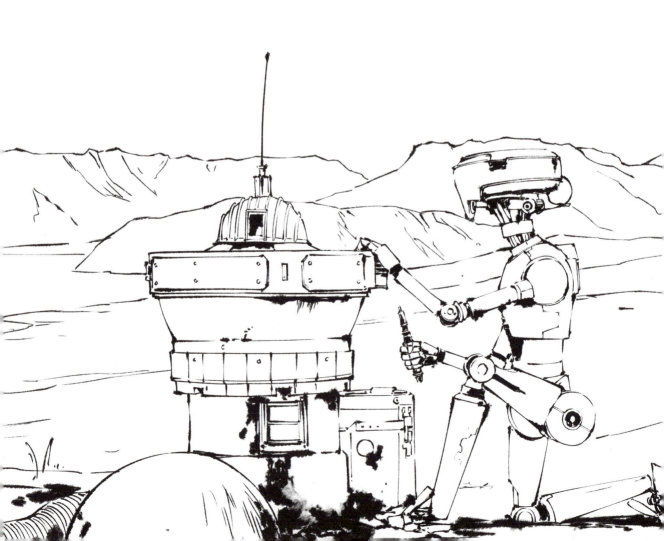